IN FOCUS

PAUL STRAND

PHOTOGRAPHS

from

THE J. PAUL GETTY MUSEUM

Anne M. Lyden

The J. Paul Getty Museum

Los Angeles

In Focus
Photographs from the J. Paul Getty Museum
Weston Naef, *General Editor*

© 2005 J. Paul Getty Trust

Getty Publications
1200 Getty Center Drive
Suite 500
Los Angeles, CA 90049-1682
www.getty.edu

Christopher Hudson, *Publisher*
Mark Greenberg, *Editor in Chief*

Library of Congress Cataloging-in-Publication Data

Lyden, Anne M., 1972–
 Paul Strand : photographs from the J. Paul Getty
 Museum / Anne M. Lyden.
 p. cm. — (In focus)
 ISBN-13: 978-0-89236-808-2 (pbk.)
 ISBN-10: 0-89236-808-X (pbk.)
 1. Strand, Paul, 1890–1976. 2. J. Paul Getty
Museum—Photograph collections. 3. Photograph
collections—California—Los Angeles.
4. Photography, Artistic. I. Strand, Paul, 1890–1976.
II. Naef, Weston J., 1942– III. J. Paul Getty Museum.
IV. Title. V. In focus (J. Paul Getty Museum)
 TR140.S7345L93 2005
 779'.092—dc22
 2005001670

Contents

Foreword

This volume in the In Focus series deals with the work of Paul Strand, one of the leading figures in twentieth-century American photography. Exploring the development of Strand's aesthetic, from his early encounters with modern art to his search for humanity in portraits of people and places, this book surveys forty years of the artist's sixty-year career.

Strand's creations first gained critical acclaim from the photographer and impresario Alfred Stieglitz, who championed the pictures in a series of exhibitions and publications, most notably by devoting an entire issue of his journal, *Camera Work*, to them. Strand was also a filmmaker and, along with fellow photographer Charles Sheeler, is credited as having made the first avant-garde film in America, *Manhatta* (1921). Strand's experience of making motion pictures had a resounding impact on his still photographs, which he continued to produce until his death in 1976. Throughout his career, Strand traveled across America, Mexico, Europe, and Africa, creating a rich legacy of prints that continue to inspire photographers today.

The artist's life was discussed in a colloquium at the Getty Center on June 18, 2004. The participants included Anne M. Lyden, Weston Naef, Naomi Rosenblum, Mark Ruwedel, Alan Trachtenberg, and David Featherstone, the moderator of the discussion and editor of the transcript. My thanks are offered to all, especially Anne Lyden, who wrote the introduction and texts accompanying the plates.

In addition to the persons named at the end of this volume, others were involved in making it possible: Julian Cox, Marc Harnly, Lynne Kaneshiro, Susan Logoreci, Ernie Mack, Eileen Mather, Ted Panken, Amy Rule, Martin Salazar, Mike Underwood, Marisa Weintraub, and Jesse Zwack. Special thanks go to Weston Naef, the originator and general editor of the In Focus series, and to former director Deborah Gribbon, who helped ensure its success.

William M. Griswold
Acting Director and Chief Curator
The J. Paul Getty Museum

Introduction

Paul Strand (1890–1976) succeeded in defining twentieth-century American photography, with a sixty-year career that spanned Pictorialism, Cubism, and Modernism. Throughout his lifetime, his interest in and passion for the medium were unwavering. His images explore the pure form of the man-made environment, the abstract and dynamic qualities found in nature, and the humanity seen in the faces of individuals and their surroundings. As Strand stated in an article he wrote in 1917 for the *Seven Arts*, "Photography is only a new road from a different direction but moving toward the common goal, which is Life."

Strand received his first camera, a Kodak Brownie, in 1902 as a gift from his father. Although Strand later recounted that at the time he was more interested in playing outdoors than making pictures, it was not long before photography featured more prominently in his life. During the years 1904 to 1909 he attended the Ethical Culture School in New York. Founded by Felix Adler (1851–1933) in the late nineteenth century, the school placed a humanist emphasis on creative, critical, and pragmatic approaches to learning. Strand not only benefited from this radical teaching but also had his first formal instruction in photography from Lewis W. Hine (1874–1940), whose images of child labor gained critical acclaim. Hine was keen to promote the artistic potential of the medium while also expounding its value as a social documentary tool, and his philosophy had an important bearing on the teenaged Strand. Hine was also responsible for introducing Strand to the Little Galleries of the Photo-Secession, directed by the great American photographer

Alfred Stieglitz (1864–1946). For Strand, this classroom visit was an important introduction to Stieglitz's ideas on art and anticipated the future relationship between the two men.

After graduating from high school, Strand worked at various jobs while continuing to experiment with the camera on the weekends. Within a few years he decided to try to support himself through photography. However, Strand said it was not until 1915 that he became a photographer, suggesting that only then did he possess the confidence to define and express his own distinct vision. Abandoning his early Pictorialist style of painterly images, he adopted a more straightforward, realistic approach to portraying the world around him. His creations show a vibrant New York cityscape, encapsulating the dynamic qualities of modern life through unusual angles and viewpoints. This shift in approach was due in part to the 1913 Armory Show, where Strand saw the daring work of Georges Braque (1882–1963), Paul Cézanne (1839–1906), Henri Matisse (1869–1954), and Pablo Picasso (1881–1973). At first these examples of modern art puzzled Strand, but he was intrigued with many of the abstract compositions and applied the same principles to his own pictures. The freshness and vitality of the resulting work impressed Stieglitz, who, in comparing it to the prevailing soft-focus style, declared Strand's photographs "pure" and "direct." Stieglitz believed so strongly in the originality of Strand's efforts that he gave the young artist a solo exhibition at his 291 gallery in 1916 and featured his prints in the last two issues of *Camera Work*, the journal he had founded in 1903. That the final volume of *Camera Work* (published in 1917) should feature only images by Strand seemed to signal that Stieglitz was appointing him as the future of photography.

Strand became part of Stieglitz's circle, which included the artists Arthur Dove (1880–1946), Marsden Hartley (1877–1943), John Marin (1870–1953), and Georgia O'Keeffe (1887–1986), all of whom believed in the expression of a modern art, one that was distinctly "American." Strand's views of New York and machine-age photographs of this time share in this sentiment. However, by the late 1920s his relationship with Stieglitz was coming under strain. The 1930s proved to be a difficult time for Strand; not only was his friendship with Stieglitz ending, his first marriage was too (he eventually married three times). Perhaps looking to ease his

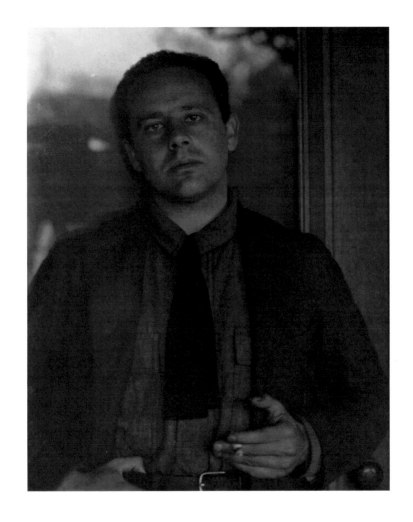

personal pain, Strand traveled to Mexico, where he spent two years working for the government as head of photography and cinema in the Department of Fine Arts of the Secretariat of Education. During this time he began filming *Redes* (Nets), a motion picture about the lives and working conditions of Mexican fishermen. Unlike his earlier avant-garde production, *Manhatta* (1921), which he made with fellow photographer Charles Sheeler (1883–1965), his films from the 1930s were more socially and politically motivated, partly in response to the bleak economic climate of the Great Depression. Strand immersed himself in making movies, joining the film group Nykino and becoming a founding member of Frontier Films, a documentary cooperative whose productions included *Native Land* (1942). He did not return to still photography until 1943.

In spite of this lull of almost ten years, the Museum of Modern Art, New York, gave Strand a one-man show in the spring of 1945 and published the first major monograph of his work, *Paul Strand: Photographs, 1915–1945*. The curator and photo-historian Nancy Newhall (1908–1974), who wrote the book, declared in its opening pages, "The work of Paul Strand has become a legend." During the 1940s, Strand, with a renewed energy, embarked on a project to photograph people and places in New England. In 1950, having collaborated with Newhall once again, he published *Time in New England*, which featured historical texts alongside his pictures. Strand seemingly had found an ideal format in which to display and disseminate his photographs. Believing firmly in the need to group images together in order to create revealing sequences of photographs that would be further illuminated—not necessarily described—by the accompanying words, he was attempting to share his images with a wide audience in the most democratic way possible: the published book.

Strand had become increasingly political over the years, and, with the rise of the House Un-American Activities Committee, he, along with many other individuals, came under scrutiny for his perceived left-wing activities. In spite of intimidation and blacklisting, Strand encouraged artists to continue to express the truth. For him, this meant expressing life as it revealed itself before his camera. In 1950 Strand left the United States, initially staying in Paris before permanently settling in Orgeval, France, where he worked until his death on March 31, 1976.

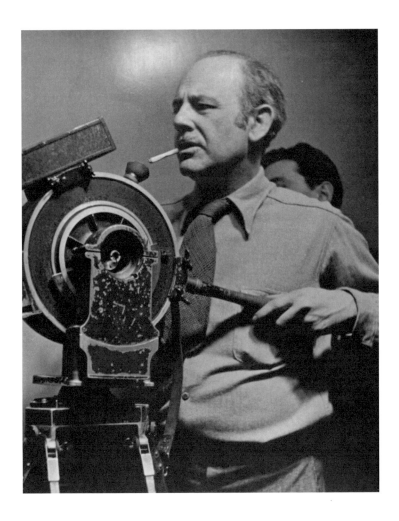

Marion Michelle (American, b. 1913).
Portrait of Paul Strand Filming "Native Land," ca. 1938.
Gelatin silver print, 14.8 × 11.1 cm ($5^{15}/_{16}$ × $4^{7}/_{8}$ in.).
© Marion Michelle. Paul Strand Collection,
Center for Creative Photography, University of Arizona, Tucson.

The time spent in France saw Strand work on more book projects: *La France de profil* (A profile of France; 1952), *Un paese* (A village; 1955), *Tir a'Mhurain* (The Land of Bent Grass; 1962), and *Living Egypt* (1969)—all of which were based on a format similar to that employed in *Time in New England*. These publications succeeded in broadening the scope of photographic literature in the twentieth century and presented the world as seen through Strand's lens: often abstract, at times heroic, and always vital.

The strength of the Getty Museum's Strand collection represents the years from 1913 through 1954, which, although an impressive span of time, does not cover the artist's last two decades of output (with the exception of a few single prints dating from the 1960s and 1970s). The majority of the Strand photographs were acquired in 1986 from several sources, but by far the largest group came from the Paul Strand Archive of the Aperture Foundation in New York. In subsequent years the Getty's Strand holdings continued to grow with key acquisitions and donations, bringing the total prints represented in the collection to 186. The largest holdings of Strand's work are found at the Philadelphia Museum of Art; the Aperture Foundation, Millerton, New York; and the Center for Creative Photography, Tucson, Arizona, where the photographer's personal archive of scrapbooks, maquettes, and correspondence is housed. The universality of his images is seen in their inclusion in numerous museums and private collections all over the world.

Anne M. Lyden
Associate Curator, Department of Photographs

Plates

PLATE I

New York

1913

Platinum print
26.4 × 24.8 cm
(10⅜ × 9¾ in.)
84.XM.894.1

When Lewis W. Hine took his class of photography students to Alfred Stieglitz's Little Galleries of the Photo-Secession in 1907, Paul Strand was only seventeen years old. On display was an exhibition featuring the work of the most prominent photographers creating art in America at this time: Alvin Langdon Coburn (1882–1966), Frank Eugene (1865–1936), Gertrude Käsebier (1852–1934), George Seeley (1880–1955), Edward Steichen (1879–1973), Stieglitz, and Clarence H. White (1871–1925). For an introduction to the art form, the visit did not come up short for the young Strand.

The Little Galleries of the Photo-Secession were located at 291 Fifth Avenue, New York. The exhibition space was established in 1905 by Steichen and Stieglitz to promote and display photography within the context of art. The Photo-Secessionists espoused the artistic potential of the medium by developing a painterly approach to their work. Through subject matter and printing processes, their photographs possessed certain aesthetic qualities that became characteristic of the movement, later called Pictorialism.

Strand's 1907 exposure to these artworks seemed to make a lasting impression on him. By 1910, having already graduated from high school, he was experimenting with soft-focus lenses and gum processes. His subject matter was typically Pictorial in nature—scenes of dreamlike landscapes celebrating beauty for its own sake, such as this one from 1913.

Made up of partially obscured trees and other, indeterminate forms, the image does not serve as a record of a specific place but is more a personal response to the landscape. While his early work shows Strand's mastery of the medium, the photographs are short on social content. His interest in Pictorialism waned, and by 1917 he wholly rejected the style, stating in an essay he penned for the journal the *Seven Arts* that it was "merely the expression of an impotent desire to paint." In this article Strand advocated an approach to photography that was true to the unique nature of the medium.

12

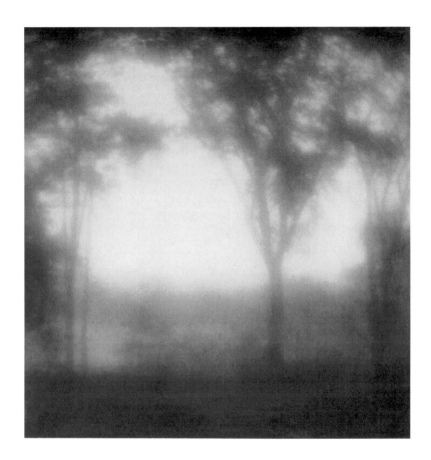

PLATE 2

City Hall Park, New York

1915

Platinum print
34 × 16.5 cm
(13 ⅜ × 6 ½ in.)
86.XM.683.94

Strand's approach to photography was already changing by 1915. Choosing a more straightforward style—one that relied less on a soft-focus lens—he was interested in portraying realistic scenes of New York that expressed the pulse and dynamism of the modern city.

Beginning in the late 1800s, Manhattan began expanding upward with skyscrapers. When the Woolworth Building opened in 1913, it was the tallest in the world. Standing at 792 feet, it was a commanding presence overlooking City Hall Park. These new structures afforded views of the city from above—a reality that was in itself modern and dynamic.

Like any resident of Manhattan at this time, Strand was aware of the impact of these buildings. Indeed, many of his photographs from this period are taken from an elevated position, no doubt in response to this new way of experiencing the city. This picture, composed of clusters of people making their way through City Hall Park,

was just one such example (see also p. 138). With his camera poised above the location, looking down on the silhouetted figures, he captured a scene of kinetic energy, where the people are not only caught in motion but also scattered across the composition from top to bottom and left to right. The bird's-eye view flattens the scene, making everything appear to be on one plane. With its nontraditional perspective and elongated format (Strand cropped the original negative), the composition evokes Japanese art, only with New York as the subject.

Although seemingly capturing the spontaneous hustle and bustle of city life, Strand was very deliberate in creating this picture, even going so far as to remove a figure from the original negative. Only a shadow remains of the individual Strand deleted below the man striding from left to right (see p. 104). Ironically, Strand, who championed a straight approach, felt compelled to manipulate the negative for the desired effect in the finished print.

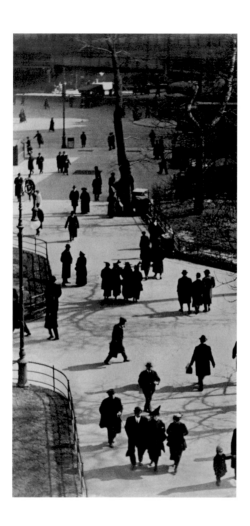

PLATE 3

New York

1916

Gelatin silver–platinum print
(on Satista paper)
24.9 × 33 cm
(9 ¹³/₁₆ × 13 in.)
86.XM.683.58

The International Exhibition of Modern Art, held in New York at the 69th Regiment Armory, drew large crowds to its galleries during the run of the show (February 17–March 15, 1913). Strand was among the throngs of people (more than a hundred thousand) who waited in line to see the work of American artists alongside that of Europeans such as Georges Braque, Paul Cézanne, and Pablo Picasso. Although at first bemused by the modern art on display, Strand was very much influenced and inspired by the new principles it promoted and began exploring the same ideas in his own photographic work.

This view from Strand's 83rd Street home is a bold, angular composition broken down into architectural facets that together create an interesting array of shapes and forms and a play of light and shadow. Abandoning traditional axioms of perspective and representation, he explored the strong diagonals found within the yard as an end unto itself. The photograph is amazingly simple in its execution yet strikingly complex in its arrangement. It was a radical departure from Strand's early Pictorialist work. Having seen examples of Strand's prints, Stieglitz offered the young photographer a show in 1916 at 291, as the Little Galleries of the Photo-Secession had come to be known. The opportunity was quite an endorsement, for no photographs had been shown at 291 since 1913, when Stieglitz had displayed his own work there. Stieglitz, who had gradually moved away from the Pictorialist style of the Photo-Secession, in spite of being its major proponent at one time, was now advocating a more direct approach in photography and saw Strand's prints as the embodiment of his own principles.

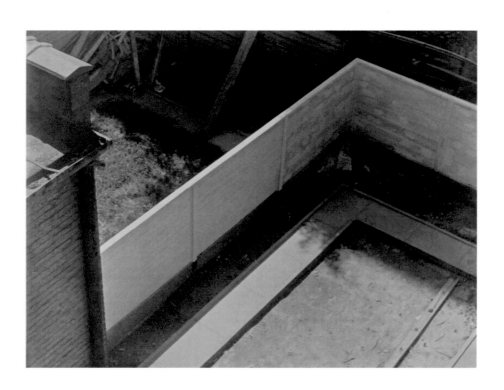

PLATE 4

Photograph

1916

Gelatin silver–platinum print
(on Satista paper)
25.7 × 28.7 cm
(10⅛ × 11⁵⁄₁₆ in.)
88.XM.15

Strand's shifting perspective on art is reflected in the austere title he assigned to this and other photographs made around 1916. During that summer he went to his family's cottage at Twin Lakes, Connecticut, where he experimented with creating a number of abstract compositions. Inspired by modern art of the time, in particular Cubism, where an object is deconstructed and visually analyzed to depict multiple viewpoints simultaneously, Strand explored the formal elements of objects within the parameters of photography. In this still life with pear and bowls, he removes the dishes from any known context, presenting them stacked together in an apparently random arrangement. The form of the pear is an important element within the composition, as it acts as a silhouette against the background of white ceramic. In doing so, it adds a layer of dimension that is otherwise missing in the flattened picture plane.

Strand was not copying Cubism, nor are his photographs mere derivatives of Picasso's or Braque's still lifes of the period. Strand was exploring the issues raised in those paintings within a purely photographic context. In a 1974 interview with Calvin Tomkins in the *New Yorker*, Strand recounted that his interest in modern art taught him "what a picture consists of, how shapes are related to each other, how spaces are filled, how the whole must have a kind of unity."

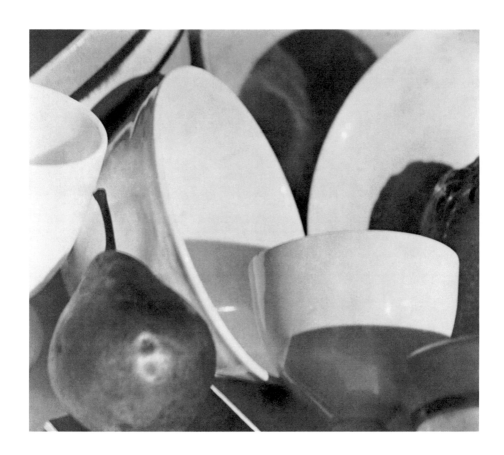

PLATE 5

Still Life with Contessa Cigarette Boxes, Twin Lakes, Connecticut

1917 gelatin silver–platinum
print (on Satista paper)
from a 1916–17 negative
33 × 19.4 cm
(13 × 7⅝ in.)
86.XM.683.59

Since his early Pictorial work, Strand favored platinum prints for their ability to record the image in crisp detail while offering a richness and broad range of tones. However, like many photographers of the time, he found it increasingly difficult to secure platinum paper, which, for economic reasons, was no longer being manufactured. Instead, a commercial silver-platinum paper, known as Satista, briefly became a substitute material. It was cheaper both to produce and to purchase and similar in look and feel to the original platinum paper.

This arrangement of Contessa cigarette boxes is an exercise in form and light. Strand removes the objects from their everyday context in order to exploit their graphic qualities (such as the bold black-and-white stripes), while at the same time exploring their dimensionality within the composition. By juxtaposing the rectangular boxes with the circular bowls, he creates a relationship that is not predicated by content or subject matter, but simple form. In this approach Strand is aligning himself with certain principles of modern art, in that he is attempting to free the objects from their given use or associated identity in order to expose their true form. In other words, the composition becomes completely objective. For Strand, photography, unlike painting, offered "absolute unqualified objectivity" that he believed to be "the very essence" of the medium ("Photography," see pl. 7).

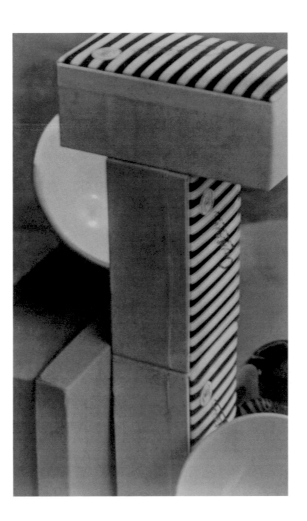

PLATE 6

**Portrait —
New York**
1916

Platinum print
33.3 × 23.7 cm
(13⅛ × 9⁵⁄₁₆ in.)
89.XM.1.1

In 1916 Strand began using a camera fitted with a false lens that would allow him to create portraits without his subjects being aware of it. He wanted to explore the notion of recording individuals close-up, without them posing. With an old brass lens attached to the side of his camera and facing forward, Strand could appear to take a photograph of something ahead of him, when in reality he was shooting at ninety degrees to his line of sight, the working lens partially hidden under his arm.

These strong and commanding portraits depict average New York citizens. Strand was now working at street level—he was not watching people from above (see pl. 2), where they are miniaturized against the urban setting. He was providing a face, an identity (of sorts), for metropolitan anonymity. Strand's photographs effectively bring light into the shadows, illuminating the existence of these residents. In *Portrait — New York*, a harsh raking light comes from the left to reveal one-half of the woman's face as she emerges from the dark background. Strand deliberately places her off center, drawing more attention to her visage, whose weatherworn lines are exaggerated in the bold light. The portraits do not— cannot—tell us who these inhabitants are, but Strand's detailed recording of their faces acknowledges a physical truth and separates the person from the masses.

In later discussing the images with the photographer Walter Rosenblum (b. 1919), Strand acknowledged that there was a "psychological difference" that was perceptible when a person was photographed without his or her knowledge. Strand's attempt to capture people without the mask that is typical of a conscious portrait achieved something new that inspired other photographers. The New York subway portraits (see p. 109) made by Walker Evans (1903–1975) using a Contax camera hidden in his overcoat were informed, in part, by Strand's street portraits, in particular the photograph of the blind woman (pl. 7).

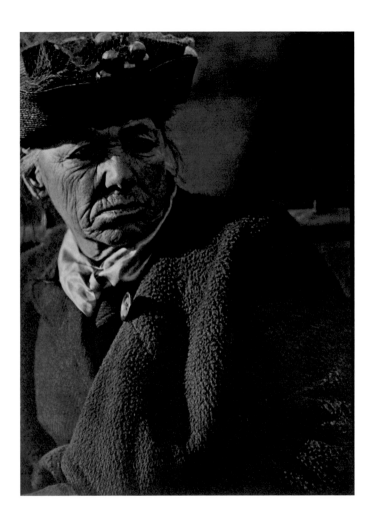

PLATE 7

Photograph—
New York

1917 photogravure
from a 1916 negative
22.4 × 16.7 cm
(8 ¹³⁄₁₆ × 6 ⁹⁄₁₆ in.)
93.XB.26.51.3

This portrait of a blind woman, part of the same series of works made with Strand's false-lens camera, is unsettling for several reasons. The whole idea of a false lens is unnecessary in this situation, given, as the viewer is led to believe from the sign, that this woman is blind and therefore presumably unable to see the photographer and his camera. Yet, there is uncertainty as to whether or not she has any vision in her left eye, which looks beyond the right frame of the composition. Strand forces the viewer to confront this woman and her plight; looking at her in this bold manner challenges us to acknowledge her presence, whereas on the street we might ordinarily ignore her. Although her existence has been recorded by the city, whose issuance of the metal medallion gives the woman license to peddle, it has effectively reduced her identity to a simple number.

This portrait was published as a photogravure print in the June 1917 issue of *Camera Work*. It was the final volume in this long-running journal, which had been launched by Stieglitz in 1903. Stieglitz had already championed the work of Strand in a previous number from 1916, stating: "His work is pure. It is direct. It does not rely upon tricks of process." Now he devoted the entire final issue to Strand, whose essay "Photography" also appeared within the pages of the deluxe publication. Echoing the words of Stieglitz, Strand said: "Honesty, no less than intensity of vision, is the prerequisite of a living expression. This means a real respect for the thing in front of him [the photographer], expressed in terms of chiaroscuro (color and photography have nothing in common) through a range of almost infinite tonal values, which lie beyond the skill of human hand. The fullest realization of this is accomplished without tricks of process or manipulation, through the use of straight photographic methods." For Strand, the false lens was not contradictory to straight photography—if anything, it allowed him to present a more honest and intense living expression.

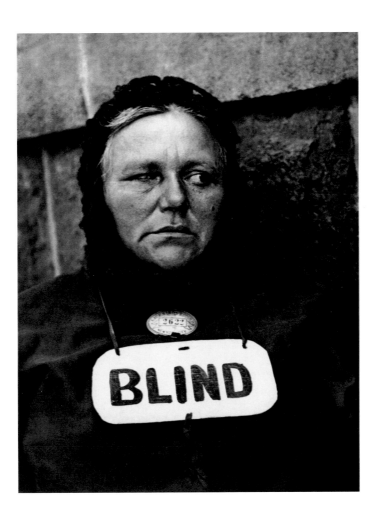

PLATE 8

Photograph —
New York

1917 photogravure
from a 1916 negative
17.1 × 22.1 cm
(6¾ × 8¹¹⁄₁₆ in.)
93.XB.26.51.9

Strand's essay "Photography," printed in the June 1917 issue of *Camera Work*, was intended for the *Seven Arts*, an avant-garde publication founded by James Oppenheim (1882–1932) and Waldo Frank (1889–1967) with support from Van Wyck Brooks (1886–1963). A short-lived effort, running from November 1916 through October 1917, it was meant to function as a sort of catalyst for American national identity against the backdrop of World War I. Indeed, in his essay, which was eventually printed in the August 1917 issue of the *Seven Arts*, Strand talks of rejecting European traditions in the hope of finding an art that is truly American. He cites *Camera Work* as succeeding to express "America without the outside influence of Paris art schools."

Arguably, Strand's photograph of this white picket fence, which also appeared in the June 1917 *Camera Work*, is an archetype of American society itself, with the fence symbolizing the ownership and division of property, a basic freedom. And yet, read simply, the image is a powerful tour de force of a bold white foreground laid down over a dark ground, something extremely innovative at this point in the history of photography. Once again, drawing on the ideals of modern art, he exploits the formal properties of the fence to create a dynamic composition that does not employ traditional perspective but yet is very much rooted in reality. In addition, the existence of the fence allowed the photographer the opportunity to experiment with the entire tonal range of the gray scale, literally working from white to black. Unlike with his early prints (such as pl. 1), where there is an evenness of values that unites the picture, he is now interested in fully exploring the black-and-white qualities of the medium.

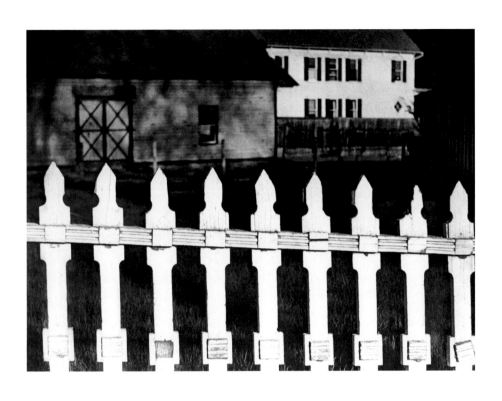

PLATE 9

Alfred Stieglitz

1922

Platinum print
24.6 × 19.5 cm
(9 ¹¹/₁₆ × 7 ¹¹/₁₆ in.)
86.XM.635

Stieglitz saw a vitality in Strand's pictures, which he described in the October 1916 issue of *Camera Work* as "keeping in close touch with all that is related to life in its fullest aspect." Although there was an age difference of twenty-six years between the two men, they enjoyed a friendship based on mutual respect and a shared love for photography. Stieglitz believed Strand offered a new and dynamic direction for the medium, while Strand greatly admired everything Stieglitz had done to promote the art.

In 1917 *Camera Work* ceased publication and Stieglitz closed the gallery at 291. As both men struggled to create photographs against the grim backdrop of World War I, their relationship became more complex, particularly regarding their mutual affection for Georgia O'Keeffe. In 1918 Strand was inducted into the U.S. Army Medical Corps, where he maintained a correspondence with Stieglitz and eagerly shared copies of *Camera Work* with his fellow soldiers. Once his term finished a year later, Strand returned to New York

and the Stieglitz circle. This circle, which included Arthur Dove, Marsden Hartley, John Marin, and O'Keeffe, was seen by many as an exclusive group. Its members were interested in finding and expressing a purely American vision. Focusing on the aspects of New York that were modern, bold, and dynamic, the artists recognized and celebrated technology within their art, seeing the new machine age as something that was distinctly of this nation.

This portrait shows Stieglitz seated in front of a seemingly abstract work of art, installed on the gallery wall behind him. The bold white triangle of the painting is repeated twice in Stieglitz's shirt and collar, creating a point of reference between foreground and background that helps to organize the composition. The strategy of posing artists before their artworks was one that Stieglitz had already employed. Here Strand is affording him the same treatment and, in doing so, effectively pays homage to the man and his achievements.

28

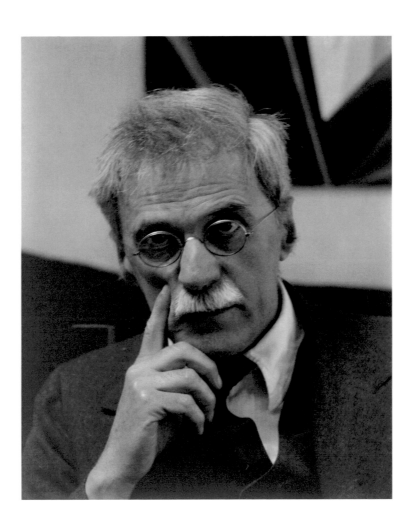

PLATE 10

Rebecca

1923

Platinum print
19.4 × 24.1 cm
(7 ⅝ × 9 ½ in.)
86.XM.683.55

Strand married his first wife, Rebecca Salsbury (1891–1968), in January 1922. She, like Strand, had attended the Ethical Culture School in New York but was several years behind him. As an artist who painted on glass and did embroidery, Salsbury shared many of Strand's interests and, through him, became friendly with both Stieglitz and O'Keeffe. From 1920 until 1932 Strand made a series of portraits of Salsbury that were somewhat of a departure from his previous work. Having sought to engage with the environment and people of New York City on a level of apparent objectivity, he was now entering into a domain that was completely subjective. His relationship with his wife naturally allowed him intimate access to her as a subject and introduced a level of interaction not usually present in his portraits.

Placing his wife in the role of a muse, Strand created a body of work that was informed by Stieglitz's series of portraits of O'Keeffe, begun in 1917. The idea of a serial portrait was something Stieglitz had been working on long before he met O'Keeffe, but with her as a subject, the concept crystallized. Viewed as a mirror, the portrait reflected not only the emotional and physical state of the sitter but, inevitably, that of the photographer too. Although Strand's portraits of Salsbury can be seen as a personal expression of their relationship as it developed over the years, many of the compositional devices and poses are already found in Stieglitz's O'Keeffe photographs.

Despite the perceived similarity to Stieglitz's work, the portraits of Salsbury are notably different. There is a distance, a barrier almost, between subject and photographer that characterizes many of Strand's images. Whereas O'Keeffe comes across as a willing participant in the poses prescribed by Stieglitz, Salsbury exhibits an awkwardness despite the intimate qualities of Strand's work.

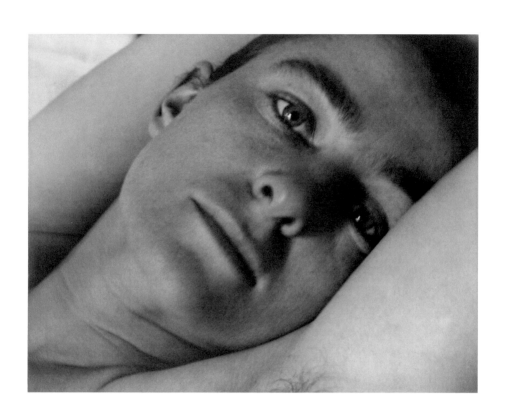

PLATE 11

**Lathe #1,
Akeley Machine Shop,
New York**

1923

Gelatin silver print
24.3 × 19.2 cm
(9 %6 × 7 %6 in.)
86.XM.686.4.1

In 1920, Strand, working with fellow photographer Charles Sheeler and his Debrie camera, created the film *Manhatta*, inspired in part by "Mannahatta" (1860), a poem by Walt Whitman (1819–1892). The movie, a chronicle of life in New York from dawn to dusk, employed title cards that featured select lines from Whitman's *Leaves of Grass*. The motion picture captured such scenes as crowds of workers rushing to their jobs from the ferry terminals ("When million-footed Manhattan, unpent, descends to its pavements"), all set against the often-dramatic viewpoints of the monumental structures and new architecture that made up the modern metropolis. Considered the first avant-garde film in America, *Manhatta* opened on July 24, 1921, at the Rialto Theatre on Broadway, where it ran for a week. Inspired by this filmmaking experi-ence, Strand, with financial help from his wife and an inheritance, purchased his own motion picture camera, an Akeley, in 1922. For the rest of the decade he earned a living shooting news footage and documenting college sports.

Strand very much admired the Akeley and made a number of photographs of the inner mechanisms of the camera as well as machinery at the Akeley shop. These pictures speak to an inherent strength and beauty found in the highly polished metal objects. Strand continued to favor a near-abstract arrangement for his compositions. Like many artists of the time, he was influenced by the machine age, and the close-up details of the machinery, such as this lathe, exaggerated the size and scale of the objects, automatically making them appear more powerful and impressive.

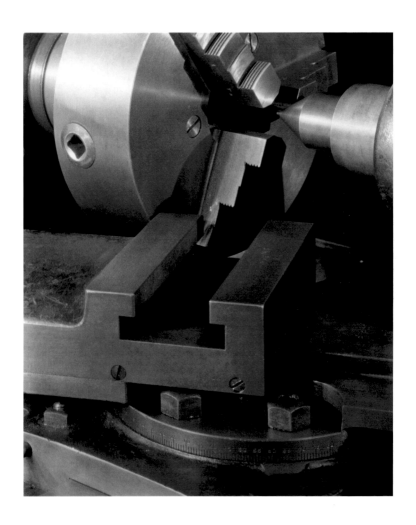

PLATE 12

**Woods,
Georgetown Island,
Maine**

1928

Platinum print
24.6 × 19.5 cm
(9¹¹/₁₆ × 7¹¹/₁₆ in.)
85.XM.200

PLATE 13

Driftwood, Maine

1928

Platinum print
24.4 × 19.4 cm
(9⅝ × 7⅝ in.)
86.XM.683.97.1

PLATE 14

Garden Iris, Maine

1928

Platinum print, gold toned
24.3 × 19.2 cm
(9⁹/₁₆ × 7⁹/₁₆ in.)
86.XM.683.104

From 1925 to 1928 Strand made numerous trips to Georgetown Island, Maine, to make photographs and visit his friend, the sculptor Gaston Lachaise (1882–1935). During this time Strand was drawn to elements of nature—tree trunks, pieces of driftwood, and plants. He approached these organic forms much in the same way he had treated the Cubist-inspired still lifes or machine-age subjects. He filled the entire ground glass with close-up views, allowing for minimum depth of field, and brought the subject to the surface of the print, literally exploiting the two-dimensional quality of the photo-graph itself. But there was a marked shift in his work. He was now rejecting the urban landscape and material objects—products of industrialization—and turning to a more fundamental subject: nature.

Strand's nature studies from the 1920s are of organic objects made up of light and dark tones, something he referred to as "chiaroscuro." During this time Strand was influenced by Clive Bell (1881–1964), the British art critic and philosopher of art, who, in his 1914 publication *Art*, advocated the idea of "significant form," which was when "lines and colour combined in a particular way, certain forms and relations of forms, stir our aesthetic emotions."

In these three examples, Strand focused on the subjects, at times with a near-microscopic zeal, attempting to record the very fiber of their existence. He was beginning to realize that these concentrated studies could, when viewed collectively, define an area, a region, or a country. In his approach to documenting the natural landscape of Georgetown Island, Strand was anticipating a working method he would apply to later pictures in France, Italy, and Scotland, where his focus was on the people who defined these regions.

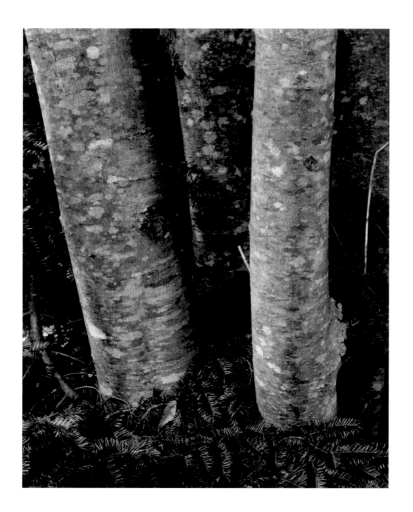

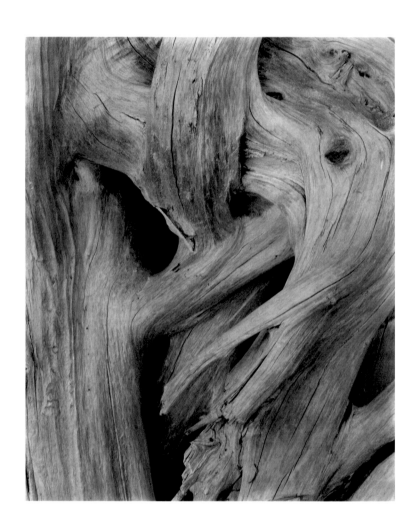

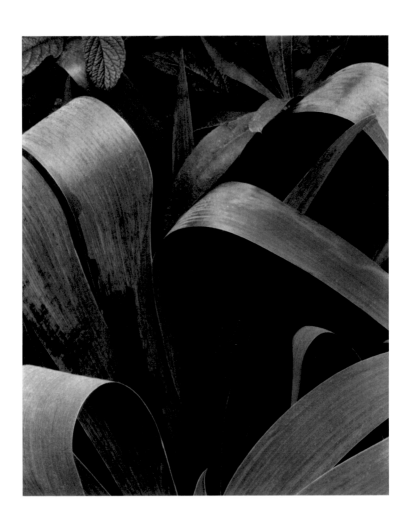

PLATE 15

The Beach—
Percé, Gaspé, Quebec
1929

Gelatin silver print
8.9 × 11.4 cm
(3½ × 4½ in.)
84.XP.208.233

In September 1929 Strand traveled to Canada and made a series of photographs primarily in and around the village of Gaspé, in the province of Quebec. Previously, Strand had focused on particular objects with an intense vision that resulted in close-up details and abstract studies. Now he was expressing an interest in the broad landscape and took up the challenge of reconciling the opposing elements of sky and land in a single frame. He began to use a smaller handheld Graflex camera for this body of work. His prints were now approximately 3½ × 4½ inches in size, yet, despite their small scale, the landscapes he depicted were often vast in scope, as can be seen in this beach view. Through his framing of the composition, the sky and water imbue the scene with a tremendous weight that defies the size of the print. Although small, the photograph cannot be dismissed as a whimsical study; instead, Strand forces the observer to think of it as a grand prospect. It is a complex arrangement where every element has been considered for the value it brings to the overall composition. The dories at the bottom left corner gently lead the viewer into the scene, where, at center, is the figure of a white horse, standing starkly against the gray waters of the Gulf of St. Lawrence. The entire print deals with contrasts of light against dark: the boats on the beach; the white horse; the vast expanse of water, which is punctuated with the silhouettes of birds and boats—all leading to the bold horizontal planes of the sky, where the uppermost clouds are in direct contrast to the beach below.

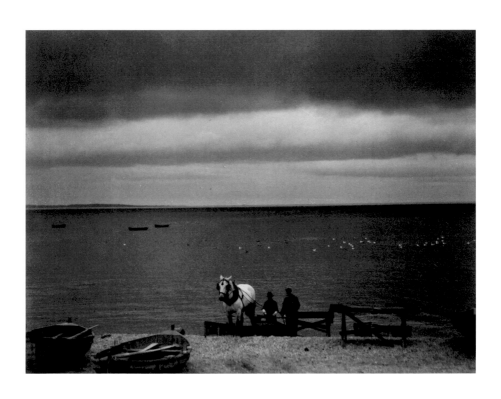

PLATE 16

White Shed,
Fox River, Gaspé

1929

Platinum print
9.2 × 11.7 cm
(3⅝ × 4⅝ in.)
86.XM.685.2.1

In this view of Gaspé there is not the grand sense of perspective or vastness of space found in *The Beach — Percé, Gaspé, Quebec* (pl. 15), but there is the same attention to the internal arrangement of the image and the interaction of key elements through the exploitation of line, shape, and mass as they are translated into black-and-white forms. Strand is approaching his photography as Cézanne did his painting: the structure of the composition and the organization of elements within that composition define the subject. Indeed, this print recalls Cézanne's painting *Houses in Provence* from ca. 1880 (National Gallery of Art, Washington, D.C.), where the picture is composed of blocks of color that create bold diagonals and forms, which in turn depict the buildings. Strand had seen various works by Cézanne

at the 1913 Armory Show in New York and acknowledged the influence of the French artist in a 1974 interview with Calvin Tomkins in the *New Yorker*, claiming: "I would say that the landscapes of Cézanne are the greatest of all, because not only is every element in the picture unified but there is also unity in depth; there is tremendous three-dimensional space that is also part of the unity of the picture space. Anyway, I became very conscious of the need to master this problem."

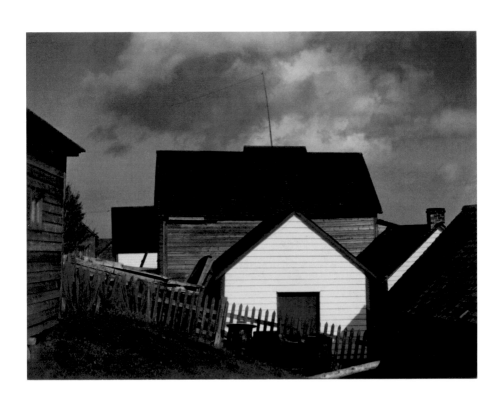

PLATE 17

John Marin

1930

Gelatin silver print
12.1 × 9.4 cm
(4¾ × 3¹¹⁄₁₆ in.)
86.XM.683.2.1

A member of the Stieglitz circle and close personal friend of Strand, John Marin was influenced by the late watercolors of Cézanne in addition to Cubism. During the 1920s Strand wrote a number of articles on Marin, who is shown here painting outdoors at Taos, New Mexico. Around this time many artists headed there at the invitation of Mabel Dodge Luhan (1879–1962), the great patron of the arts who resided in the Southwest. Strand first met her in 1926 and visited the region from 1930 to 1932. Like Marin and many of the artists gathered there, Strand was inspired by the vast landscape, which was so different from that of the eastern seaboard.

As he became engaged with the Southwest, Strand was slowly becoming disengaged from Stieglitz. The relationship between the two men had begun deteriorating in the late 1920s and eventually came to an end by the spring of 1932, after Strand exhibited prints at Stieglitz's An American Place. Strand felt that Stieglitz had not successfully promoted the exhibition, which included paintings on glass by Rebecca Salsbury, and was apparently not wholly supportive of the work on display. It was the end of a friendship and an era. Strand was no longer looking to Stieglitz as the important, omnipotent voice in photography. As Stieglitz's work became more introspective, Strand was seeking to represent the world at large. Enlivened by new ideas and people, he turned for advice to Harold Clurman (1901–1980), director of the Group Theatre in New York. The company was inspired by the Moscow Art Theatre and developed a collective approach to acting, in addition to addressing contemporary social issues in its plays.

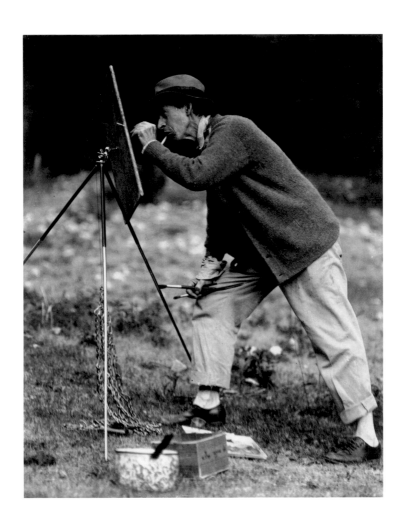

PLATE 18

**Ghost Town,
Red River,
New Mexico**
1931

Gelatin silver print
9.4 × 12.1 cm
(3 ¹¹⁄₁₆ × 4¾ in.)
86.XM.683.65.1

Red River, situated at the southern edge
of the Sangre de Cristo Mountains in New
Mexico, started as a gold mining camp in
the 1890s. In just a few years it had grown
to the size of a small town, boasting such
amenities as saloons, general stores, hotels,
a dance hall, and a hospital. By the time
Strand visited the town in the early 1930s,
the mining boom had long since passed,
having left in its wake a sleepy little hamlet,
which was now changing into a popular
mountain retreat.

Strand was interested in the area's
natural beauty and the abandoned structures
left over from the mining days. In writing to
his friend Herbert Seligman during the
summer of 1931, Strand spoke of the false-
front buildings in Red River representing a
courage and dignity of a past life. As he had

previously initiated in Gaspé, Strand was
now continuing to explore the idea of
recording a place that was separate from the
modern world.

Here, working with his versatile
Graflex camera, Strand fills the composition
with a boarded-up building, the weathered
wooden clapboards washed in strong sun-
light. The work is reminiscent of Charles
Sheeler's studies of barns in Bucks County,
Pennsylvania, from 1917, but Strand goes
a step further and removes any contextual
information from the scene. He brings
everything to the foreground and omits per-
spectival depth so that the resulting abstract
composition appears on one plane, giving
the surface of the print a decorative quality.

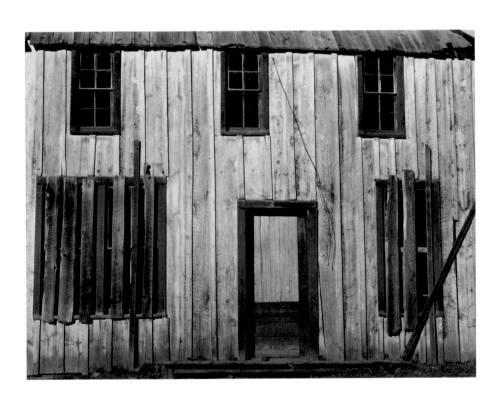

PLATE 19

Rancho de Taos Church, New Mexico

1931

Platinum print
11.7 × 14.9 cm
(4⅝ × 5⅞ in.)
86.XM.686.1

The church of San Francisco de Assisi in Rancho de Taos, New Mexico, completed in 1755, became famous in the twentieth century as an icon of pure form. A popular subject for many artists over the years, including Georgia O'Keeffe, the site was photographed numerous times by Strand. In this view the monumental structure of the adobe building is barely contained within the composition. Strand is interested in harnessing the energy of—or perhaps even instilling energy into—the arrangement by keeping it tight and omitting much of any outside context. Once again, the smallness of the print and the largeness of the subject are at odds with each other. By using the smaller size, yet filling the entire frame, Strand succeeds in magnifying the subject. In a sense it demands more attention from the viewer, who is forced to consider and ultimately reconcile the relationships between size and volume, much in the same way that the artist considered these elements when composing the picture. Indeed, Strand recounted in a lecture, presented in Chicago in 1946, that he was attempting "to see whether you couldn't get a very big feeling into a small thing."

Viewed independently, and collectively, the New Mexico images reflect a major development in Strand's overall approach to photography, in that his previous methods coalesced into one distinct aesthetic. Applying the same principles he initially explored in his abstract still lifes from around 1916, Strand created compositions that explored the formal elements of the subject by using shape, mass, texture, and light as defining properties. In his repetitive photographing of the landscape and architecture, he essentially created a sense of the place, almost like his detailed nature studies from the 1920s, only now his vision had expanded partly in response to the vastness of the subject.

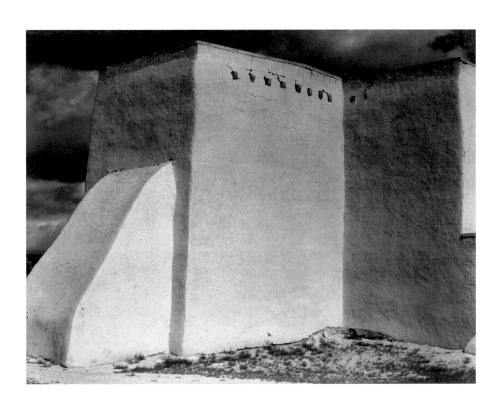

PLATE 20

Hacienda, Saltillo, Mexico
1932

Platinum print
24.4 × 19.2 cm
(9⅝ × 7⁹⁄₁₆ in.)
86.XM.683.69

After his break with Stieglitz in the spring of 1932, Strand and his wife left New York, hoping to settle in the Southwest. Their marriage was dissolving, however, and by the fall Strand departed for Mexico, where he would stay until 1934. Invited there by Carlos Chávez (1899–1978), composer, conductor, and head of the Department of Fine Arts for the Mexican Secretariat of Education, whom he had met previously in Taos, Strand arrived in the country with his marriage to Rebecca over and his friendship with Stieglitz now estranged. It was a definitive moment in the artist's life, one that would mark a shift in his approach. Seeking inspiration in a new environment, one free from the modernizing influences of America, he put his personal losses behind him and focused on his work. His interest in nonindustrialized communities would continue for the next forty years, proving to be a constant theme in his art.

No sooner had he crossed the Mexican border from Texas, Strand began creating photographs in Saltillo, where he stayed for a few days before heading farther south. In this view of the town, Strand is interested in the formal properties of the scene and exploits the natural framing device of the doorway to provide an overall structure for the composition. The dark threshold leads to an open courtyard where light from above illuminates the rustic bell and rests on the tips of the tree. The viewpoint is one of an outsider looking in and may be interpreted as symbolic of Strand's own experience on this Mexico trip.

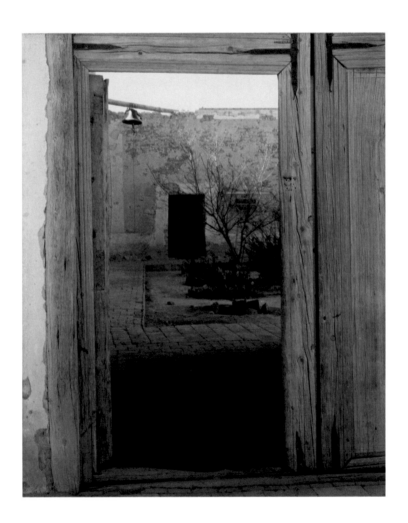

PLATE 21

Village, Tlaxcala, Mexico

1933

Platinum print
11.4 × 14.6 cm
(4½ × 5¾ in.)
87.XM.150

PLATE 22

The Sisters, Ocoyoacac, Mexico

1932

Platinum print
14.8 × 11.7 cm
(5¹³⁄₁₆ × 4⅝ in.)
86.XM.683.8

PLATE 23

Seated Man, Uruapan del Progreso, Michoacán, Mexico

1933

Platinum print
14.9 × 11.7 cm
(5⅞ × 4⅝ in.)
86.XM.683.67

Traveling around Mexico, Strand was interested in documenting the life he encountered in the country's numerous small towns. In *Village, Tlaxcala, Mexico* he records the simple architecture of the buildings, which, devoid of ornamentation, stand starkly in the bright sunlight. The weighted existence of the structures is in contrast to the ephemeral quality of the lone white cloud passing above.

Strand was also interested in capturing the steadfast qualities of the people. He was searching for those individuals whose lives were marked by struggle, persons who sought to preserve themselves and their customs despite the changing world around them. By moving closer to the subjects and filling his frame with their presence, Strand seems to acknowledge their inherent heroic qualities, as shown in plates 22 and 23. There is little contextual background in the photographs; the poses, faces, gestures, and costumes are dispassionately recorded against abraded walls, as if to further suggest the hardships the people endure.

Strand's Mexican portraits recall the series of Newhaven photographs David Octavius Hill (1802–1870) and Robert Adamson (1821–1848) made between 1843 and 1847. Strand was familiar with some of their pictures, which were published as photogravures in *Camera Work*, and in 1931 he had written a review of Heinrich Schwarz's book *David Octavius Hill: Master of Photography* for the *Saturday Review of Literature*. While the newness of the photographic medium may have engendered a natural and spontaneous response to Hill and Adamson's camera in 1843, Strand could not be assured of such a pure and genuine reaction almost one hundred years later. He reverted to the working method he had first employed on the streets of New York in 1916, this time utilizing a special mirror lens inside the camera. The result was that his subjects were not aware, for the most part, that they were being photographed, so their appearance is completely candid and unprompted.

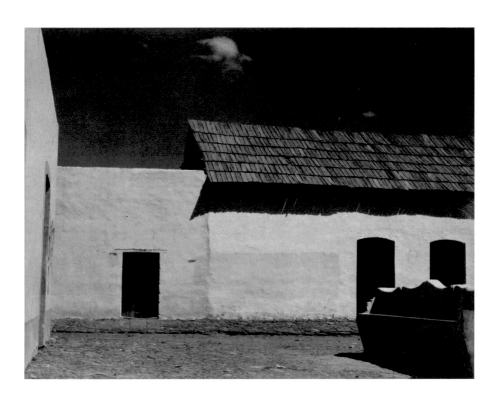

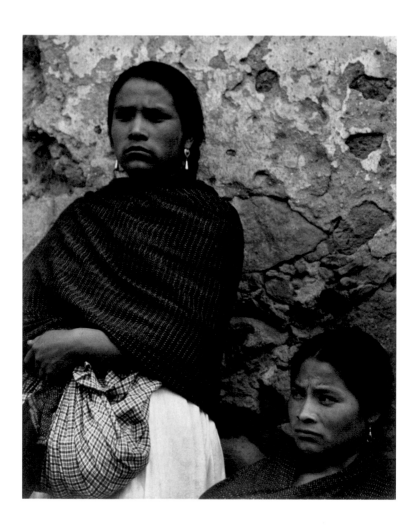

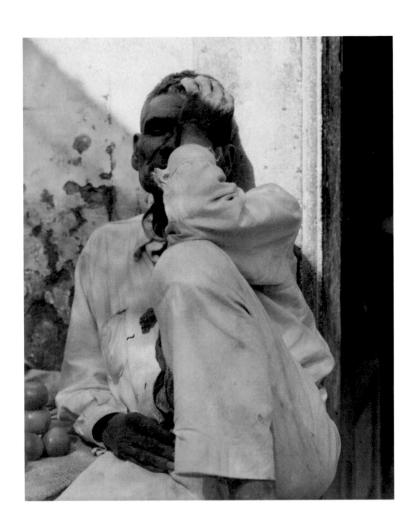

PLATE 24

Cristo Figure with Crown of Thorns, Mexico

1933

Platinum print
24.6 × 19.2 cm
(9 ¹¹/₁₆ × 7 ⁹/₁₆ in.)
84.XP.208.52

While in Mexico, Strand was intrigued with the various religious icons that adorned many churches he visited. Although born a Jew, he found himself drawn to symbols of Christianity. These wooden sculptures, known as *bultos*, depicted Christ and the various saints and possessed an amazing degree of human likeness. Strand felt that the figures were imbued with a vitality that was in part due to the intensity of people's devotion to them.

Strand's socialist views were continuing to coalesce during his time in Mexico, as he recognized the need for his art to reach a broad audience. In February 1933 he was given a solo show at the Sala de Arte of the Secretariat of Education in Mexico City. The exhibition featured fifty-four platinum prints of New Mexico, Colorado, and Maine and proved to be popular with the general public, whom, Strand noted, were truly diverse in their social backgrounds. Two months later Carlos Chávez appointed Strand the head of photography and cinema at the Department

of Fine Arts. He shortly thereafter began planning a series of films intended to document life in Mexico as experienced by different kinds of laborers. Fishermen became the subject of the first production, *Redes*, which was set in the small village of Alvarado in Veracruz. Work began on the movie in February 1934 and continued until December, at which point the newly elected government dismissed Strand from his position, and he returned to New York.

The images Strand gathered during his time in Mexico were later compiled into a portfolio of hand-pulled gravures, which he produced in 1940 with the help of his second wife, Virginia Stevens (b. 1912?), whom he had married in April 1936. *Photographs of Mexico* was released in an edition of 250 copies, each containing twenty prints. It marked the beginning of Strand's desire to group his images together into publications, which had the potential to reach a larger audience than any single print could.

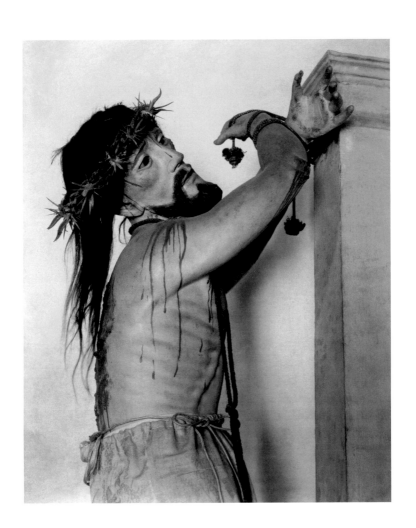

PLATE 25

Louiseville, Quebec
1936

Platinum print
24.3 × 19.2 cm
(9 9/16 × 7 9/16 in.)
86.XM.683.4

Strand returned to New York in December 1934, but he continued with *Redes* (which was released in the United States in 1936 as *The Wave*), embarked on a trip to Russia to work with the famed filmmaker Sergei Eisenstein (1898–1948), and began serving as a cinematographer for Pare Lorentz (1905–1995) on his documentary film *The Plow That Broke the Plains* (1936). By the summer of 1936, however, Strand was once again photographing with a still camera and was back in Quebec, where he made a series of portraits and landscapes.

In this particular composition Strand's attention seems to rest with the white barn in the distance. He positioned his camera in front of a wooden fence, which fills the entire bottom half of the photograph and acts as a barrier to the distant view. This creates a tension, for the observer is invited into the open vista but prevented from getting there by the heavy presence of the gate. The whole arrangement combines Strand's interest in the abstract and in the natural landscape. The deliberate juxtaposition of foreground and background views shows the influence of cinema, with its potential for interplay between near and far.

Strand himself was moving between the divergent perspectives of cinematography and photography, and, in fact, the late 1930s to early 1940s was a period devoted more to the moving image than to still photography. In 1935 he joined the film group Nykino and in 1937 became one of the founding members of Frontier Films, a documentary cooperative based in New York. He worked on several movies, the most successful of which was *Native Land* (1942), which began filming in 1938. A scathing commentary on contemporary labor conditions and corporate antiunion activity, it championed the freedoms declared at the founding of the American nation and encouraged people to stand up and protect these values, which were increasingly under threat.

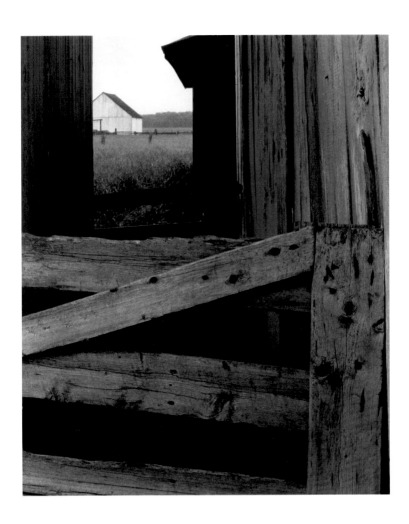

PLATE 26

**Barn Window and Ice,
East Jamaica, Vermont**
1943

Gelatin silver print
19.4 × 24.3 cm
(7⅝ × 9⁹⁄₁₆ in.)
86.XM.683.71

PLATE 27

Latch, Vermont
1944

Gelatin silver print
24.3 × 19.2 cm
(9⁹⁄₁₆ × 7⁹⁄₁₆ in.)
86.XM.683.13

PLATE 28

**Spruce and Lichen,
Maine**
1945

Gelatin silver print
24.1 × 19.1 cm
(9½ × 7½ in.)
86.XM.686.3

In 1943, after ten years of cinema work, Strand returned to still photography full time. Using a five-by-seven-inch Graflex and an eight-by-ten-inch view camera, he commenced creating images mainly in Vermont but very soon began traveling all over New England. In spite of a whole decade making motion pictures, Strand easily readjusted to photography. He continued with earlier themes of barns and wooden structures, but his abstract arrangements were now bolder and simpler than anything preceding.

As can be seen in plates 26–28, Strand completely focused on the foreground, removing all contextual information so as to present the viewer with only the window of a barn, not the whole barn; only the latch of a door, not the whole door; only the lichen on a tree, not the whole tree. He succeeded in capturing a tremendous amount of detail, filling the frame with the virtually palpable elements of frosted glass, hewn wood, and rough bark. His concern was to record the very essence of the subject, be it inanimate or a living, growing thing.

Strand had his first retrospective exhibition at the Museum of Modern Art, New York, in the spring of 1945. At this time he was working with the historian Nancy Newhall, who was acting curator of photography while her husband, the historian Beaumont Newhall (1908–1993), was fighting in World War II. Together, Strand and Nancy Newhall, who had written the first major monograph on the photographer (to accompany the exhibition), conceived the idea of publishing a book of his prints based only on New England.

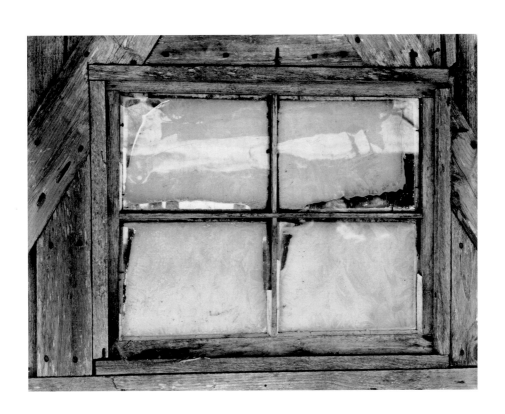

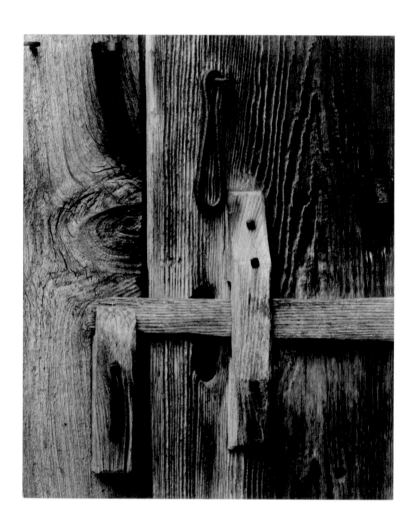

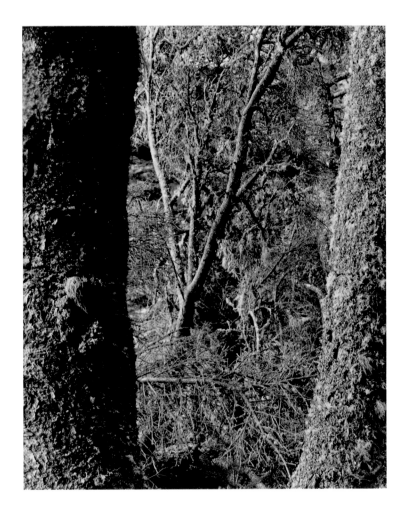

PLATE 29

Trawlers, Maine

1946

Gelatin silver print
11.7 × 14.9 cm
(4⅝ × 5⅞ in.)
86.XM.683.101

The New England project was an extension
of Strand's earlier endeavor in publishing
Photographs of Mexico. The key difference
was that he was traveling with the specific
intention of creating pictures for the book,
unlike the Mexican portfolio, which was
conceived after the prints were amassed.
Encouraged by the success of his prior
experience, Strand wanted to produce
a volume that had the potential to include
more pictures and reach an even wider
audience. Beginning in 1945, he traveled
from Connecticut to Maine, capturing
images that, as he stated in the book's pref-
ace, invoked the "spirit of New England
which lives in all that is free, noble, and
courageous in America."

Plates 29–31 were included in the
finished book, which was published in 1950
under the title *Time in New England.* In
plate 29, the masts of the fishing trawlers on
the coast of Maine create a weblike effect
across the gray sky. It is difficult to make
out the individual masts and rigging, but
Strand is not attempting to distinguish each
fishing boat. Instead, he invokes the feeling
of an entire fleet. Although the vessels
are at rest, the succession of diagonals adds
energy to the scene.

Strand and Newhall worked together
as a team in making the book. He was
responsible for creating the photographs;
she was in charge of researching and
selecting the passages that would accompany
the images. Pairing the visual and literary
forms was a subtle exercise. The photo-
graphs were not mere illustrations to
the texts, nor were the texts an elaboration
on the pictures. Rather, each form was
intended to complement the other and in
the process reveal and provide intellectual
insight into the larger theme, which was
an attempt to define and articulate America.

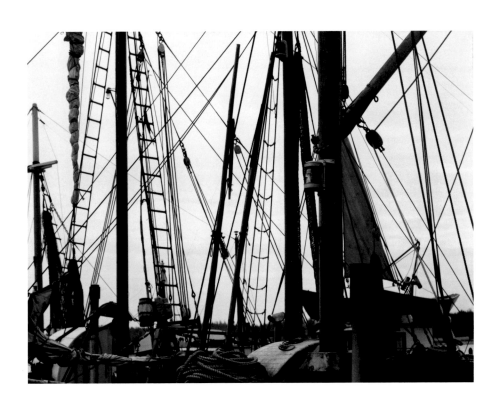

PLATE 30

Open Sea,
Cape Split, Maine

1946

Gelatin silver print
11.7 × 14.8 cm
(4⅝ × 5¹³⁄₁₆ in.)
86.XM.683.107

Strand and Newhall kept up a frequent correspondence while he explored New England. In one letter dating from June 1946 he spoke of the difficulty of capturing the ocean: "The sea remains a tough problem. You really have to live with it and be ready for the dramatic moments when and if they come. None so far." The notion of waiting for the right moment was an important one for Strand, who acknowledged somewhat sardonically that while the wait was not measured in years, it was a wait all the same. The calmness that must have accompanied such lengthy lingering is evident in many of the prints from this period.

This serene seascape from Maine is reminiscent of Strand's expansive landscapes from the New Mexico countryside. While the vision was grand, the print is small, a creative decision that has the effect of harnessing nature. However, the strong uninterrupted horizontals in the composition—the water, skyline, and dramatic clouds—create a rhythm of repetition, suggesting that the scene continues beyond all four edges of the frame, creating an almost infinite vista.

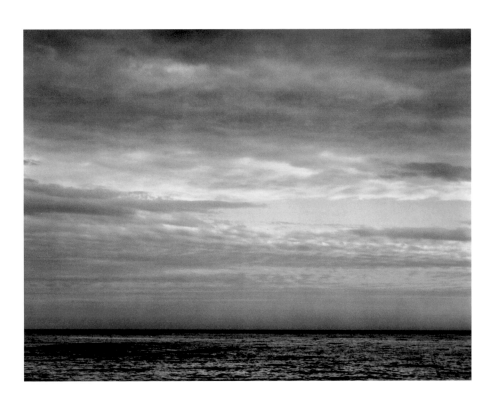

PLATE 31

**Apple Tree —
Full Bloom**
1947

Gelatin silver print
19.2 × 24.3 cm
(7⁹⁄₁₆ × 9⁹⁄₁₆ in.)
86.XM.683.9

After World War II the political climate
in America became increasingly restrictive,
fueled in part by irrational fears based on
the threat of communism spreading
throughout the nation. At this time many
organizations were blacklisted by Attorney
General Tom C. Clark, including New York's
Photo League, a group that Strand had been
involved with since the late 1930s. Outraged
at the aggressive attack on the association's
artistic and civil freedoms, Strand spoke
at a meeting held on December 16, 1947, at
the Hotel Diplomat in New York, where he
addressed the members, urging them to
continue presenting the truth in spite of the
attempts "to silence us." Fellow photographer
Ansel Adams (1902–1984) also spoke at
the meeting and encouraged photographers
to keep working, stating, "Their theme
must be America—the land, the people, the
power of Democracy, the human promise
of a free society."

Strand, who over the years had become
increasingly political and leftist in his views,
was already expressing his love of America,
and all that it stood for, through his pho-
tographs. In the opening pages of *Time in
New England* he wrote that the region
represented the many "thoughts and actions
that have shaped America for more than
three hundred years," which included the
"freedom of the individual to think." His
book was intended as a commentary on the
country, and the pictures represented
its freedom, beauty, and dynamic qualities.

Through Strand's eyes the apple tree
not only represented an important feature of
life in New England but also symbolized
the heritage of the nation, whose very foun-
dations were established there. The fact
that the tree is caught in blossom makes the
symbolism all the more potent: bursting
with energy, its cycle of growth continues,
as does the hope for the republic.

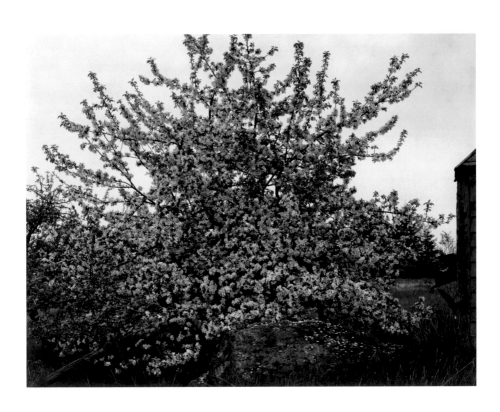

PLATE 32

Houses, Locmariaquer, Finistère

1950

Gelatin silver print
24.3 × 19.1 cm
(9 ⁹⁄₁₆ × 7 ½ in.)
86.XM.683.20

Around 1950 Strand was nurturing the idea of photographing a village, where he might focus on the idea of community. This notion was inspired somewhat by the 1915 book *Spoon River Anthology* by Edgar Lee Masters (1869–1950). However, Strand was not hopeful that he would find his village in America at this time, due to the inhospitable political climate. He decided to leave the United States and settle in France with the photographer Hazel Kingsbury (1907–1982), who became his third wife in February 1951. Over the course of several years he traveled across France searching for the suitable village, only to discover that his pictures captured the whole country instead.

Strand published these photographs in a book titled *La France de profil.* Issued in 1952, it was accompanied by the writings of the French poet Claude Roy (1915–1997). This was yet another opportunity to combine words and images, following the pattern set by *Time in New England.* Strand shunned the typical scenes of France that were often synonymous with the country, choosing not to focus on popular icons or places of historical interest. According to Roy's preface to the book: "Paul Strand did not enter French life as someone coming *from the outside.* . . . He simply sought to penetrate it."

This spare and unusual image of houses at Locmariaquer is accorded a full page in the book. Printed opposite the picture are sayings found on French sundials, such as "Cherish the light" and "Life like shade passes in but a few hours." Strand has chosen to photograph a side of the buildings that would be rendered flat were it not for the play of light casting subtle shadows on the forms and creating shallow reliefs within the composition. Through these shadows the passage of time is recorded on the face of these houses, already weathered from age, effectively turning the structures into a large sundial.

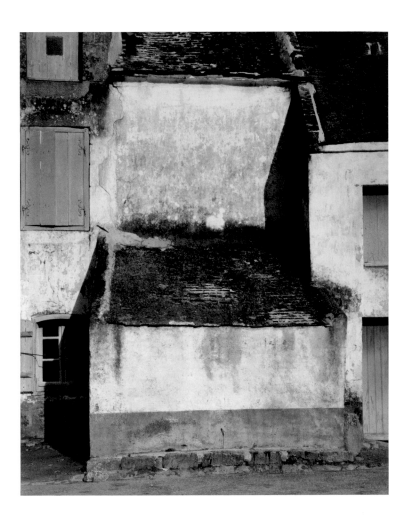

PLATE 33

In Botmeur, Finistère, France

1950

Gelatin silver print
24.3 × 19.4 cm
(9 $\frac{9}{16}$ × 7 $\frac{5}{8}$ in.)
86.XM.683.19

In the book *La France de profil* this particular image appears opposite a poem by Claude Roy. The words were arranged on the page so as to follow the silhouettes of the buildings and the large elm tree (see p. 128). The photograph and poem are interesting companions: each simultaneously complements and resonates with the other. Strand's picture came first and was inspiration for Roy's text, which conjures up images of longing while dealing with opposites. However, the photograph goes beyond the words to reveal the universal theme of time and its passing. The transit of time is intimated by the trees, which exemplify the cycle of life itself: they continue to grow, shed their leaves, and spring new buds. The buildings remain fixed and unchanging, except for the degradation of their facades.

Strand and Roy traveled around the country, from Brittany to the South of France, seeking out places and things of interest for their project. Strand was convinced that the book format was a perfect medium for showing his work, and, seen as an extension of his vision, the production of the book was highly important to him. He was disappointed with the quality of reproductions in *Time in New England* and consequently insisted on overseeing all production of the French plates at the printer in Lausanne, Switzerland. This intensive managing of the project was something he would repeat for all his subsequent publications.

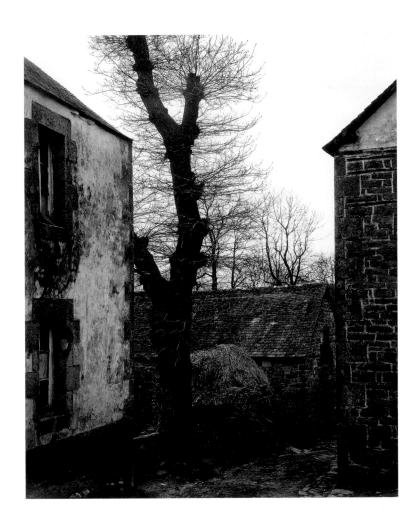

PLATE 34

M. Pelletier,
Gondeville, Charente

1950

Gelatin silver print
15.2 × 11.7 cm
(6 × 4⅝ in.)
86.XM.683.15

As Claude Roy pointed out in the preface
to *La France de profil*, the beauty of Strand's
photographs came from his acquaintance-
ship with the country and its people. As
Strand patiently made his way around France,
he soaked up the landscape and architec-
ture, the people and customs, of each region
to the point that he presented images of
France, not to initiate or remind the tourist,
but for the French themselves to recognize
as familiar. He hoped to accurately record
a place only after having understood it.
Writing about his work in an article for
U.S. Camera Yearbook 1955, Strand acknowl-
edged that "to know a land somewhat, its
special character, the qualities which
make its individuality, the temperament and
life of its people, is a process of gradual
absorption, of sympathetic perception." This
process of seeing and absorbing must have
presented a challenge, given the fact that
he was unable to communicate in the native
language (Strand spoke Spanish but not
French). Yet, arguably this language barrier
worked in his favor, as it ensured a degree
of objectivity.

Unlike his surreptitious portraits
from New York and Mexico, a lot of Strand's
work from this period shows an engage-
ment with the sitter. With the help of Hazel
Kingsbury, who did most of the social
interaction with the people, Strand actively
arranged his portraits. The result is that
many of the sitters stare straight at the
camera, fully acknowledging the photogra-
pher's presence yet possessing a remarkable
degree of naturalness. Throughout his
career, Strand was interested in capturing
the candor of his subjects, and at first this
was achievable only by clandestine prac-
tices. Now he was able to evoke this quality
from his sitters directly.

The people Strand chose to photo-
graph were often strong, heroic characters
who seemingly had lived hard, laborious
lives yet remained resilient and steadfast.
These traits are present in this portrait
of M. Pelletier, who boldly stares out at the
camera despite the cracked right lens of
his eyeglasses.

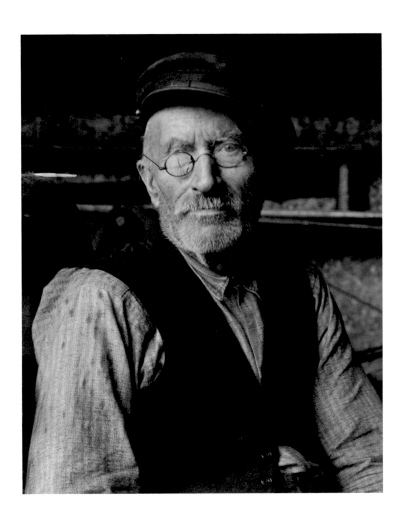

PLATE 35

Four Fishermen, Douarnenez, Finistère

1951

Gelatin silver print
11.7 × 14.9 cm
(4⅝ × 5⅞ in.)
86.XM.686.2

As a subject, the portrait of these four French fishermen recalls the work of Hill and Adamson, who, during their brief partnership in the mid-1840s, documented the fisherfolk of Newhaven, a small village on the outskirts of Edinburgh, Scotland. At the time, Newhaven was seen as a good example of a close-knit working-class community, one that, in spite of its hard existence, was able to sustain a moral, respectable way of life. Strand identified with Hill and Adamson's desire to photograph the people of Newhaven, as it was very similar to his own desire to capture an ideal community. In addition, Strand felt that the Scottish photographs revealed an honesty and dignity that spoke of "individual human worth."

Douarnenez, a small town in Brittany made up of four villages that merged in 1945, has a rich history dating back to the Middle Ages and is known for its fishing and canning industries. Interestingly, given Strand's own political awareness, it was the first town in France to elect a communist mayor, Sebastien Velly (1878–1924).

In this study Strand compresses the four fishermen within the borders of the photograph. Although peering out from underneath their hats, none of them look directly at the camera. They do not appear to be engaged by the artist or even aware of his presence; rather, they seem lost in their own thoughts. Faces weatherbeaten and beards white with age, these ancient mariners are the living legacy of the small fishing town.

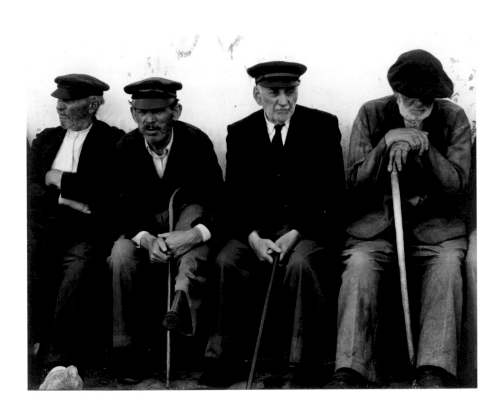

PLATE 36

Street Detail, Southern France

ca. 1950

Gelatin silver print
11.7 × 14.9 cm
(4⅝ × 5⅞ in.)
86.XM.683.21

Strand advocated a direct approach to pho-
tography, one that would present an
objective reality in a simple, straightforward
way, without any manipulation of process
or obfuscation of fact. The tenacity with
which he approached his subjects is evident
over a period of forty years. He would ignore
the obvious and look to the archetypal,
at times commonplace, subject that spoke to
him or, as he stated, that chose him.

Strand recorded many old storefronts
in France, some of which have long since
disappeared. Oftentimes the images were
absent of people, such as here, but the
empty bench and mysterious entryways
suggest the presence of life, although it has
momentarily retreated into the darkened
doorways. Doors and windows were a
particularly favorite subject for Strand, who

photographed them throughout his career.
They fascinated the artist as structural
definitions of human existence, and
he treated them as abstract elements unto
themselves. Whether it was an abandoned
building in a ghost town in New Mexico
(pl. 18), a frosted window in Vermont (pl.
26), or the latch of a door in New England
(pl. 27), they all are evidence of humanity,
representing the men and women who
utilized those buildings.

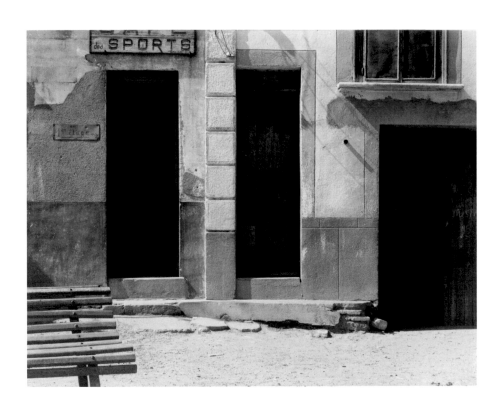

PLATE 37

The Lusetti Family, Luzzara, Italy

1953

Gelatin silver print
11.7 × 15.1 cm
(4⅝ × 5¹⁵⁄₁₆ in.)
84.XM.894.2

In 1953, still searching for his ideal village, Strand ventured to Italy, where he finally decided on the community of Luzzara after Cesare Zavattini (1902–1989), the Italian filmmaker, introduced him to the place. The two men had met earlier, in 1949, at the International Film Conference held in Perugia, Italy. Strand wanted to continue with the now-successful combination of images and words and asked Zavattini to assist him with this particular project. Unlike the previous publications, which were broader in scope, this volume focused specifically on one site and its residents. The resulting photographs and text were published in 1955 as the book *Un paese*.

When Strand was in Luzzara, it was less than a decade after the end of World War II. The pain and sorrow of the conflict were still very tangible for most towns-people, all of whom had been affected in some way. In this portrait of the Lusetti family, Anna Spagiari Lusetti is surrounded by four of her sons: Bruno, Guerrino, Afro, and Remo. Her story is one of personal loss and hardship. Married at eighteen, she bore fifteen children, four of whom died young. Her husband, after enduring years of politically motivated beatings, died on Christmas Eve in 1933, and all but one of her sons fought in the war. At the time of this photograph, the mother and five of her offspring were living together in the small house, barely surviving on the little money they made from working the land. Strand deliberately arranged the composition, placing the sons around their mother, who stands erect in the doorway, her strong features visible in their faces.

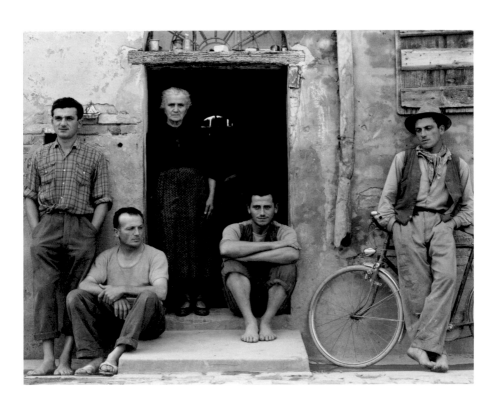

PLATE 38

Lusetti's Brother, Luzzara, Italy

1953

Gelatin silver print
14.9 × 11.7 cm
(5⅞ × 4⅝ in.)
86.XM.683.30

There were eight men in the Lusetti family; Strand primarily dealt with only one of them, Valentino. He spoke English, having learned the language from American soldiers while a prisoner of war, and consequently served as Strand's guide and interpreter. This photograph of one of Valentino's brothers is typical of Strand's portrait technique, with the subject being shown half-length and relatively close-up against a neutral background. The man's face is just as weatherworn as the decaying wall behind him. The photographer positioned his camera so that the man's portrait would be at eye level. There is no looking down on the subject, nor is he elevated within the composition to suggest adulation. Quite simply, the peasant is treated as an equal.

Strand spent over a month in Luzzara photographing the people, the village, and its environs. When he finished, he presented the images to Cesare Zavattini, who, in turn, went to Luzzara and interviewed the inhabitants. Even though Zavattini had been born there, he too enlisted the help of Valentino to guide and introduce him to the local residents. Their stories, which are told in the first-person voice, accompany the photographs and offer insight into the subjects' lives and history.

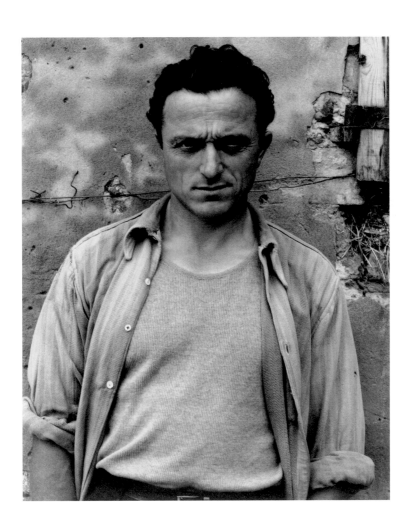

PLATE 39

Tailor's Apprentice, Luzzara

1953

Gelatin silver print

14.9 × 11.9 cm

(5⅞ × 4¹¹⁄₁₆ in.)

86.XM.685.1

Luzzara, located in the Po Valley, was an economically depressed region of northern Italy. The flatness of the river basin and the level of poverty in the area struck Strand, but he saw something wonderful in the people and sought to capture it in his portraits. Whereas the picture of Valentino Lusetti's brother (pl. 38) expressed the joys and sorrows of the man as written in the lines of his face, this image of a tailor's apprentice, Novella Pedrolina, depicts the freshness of youth, as yet uncorrupted by life. She is framed at right by a sapling, perhaps meant to symbolize her immaturity. The viewer's attention is called to the straw hat the girl clutches, which stands out against her simple black dress. Some of the residents of Luzzara made a living from braiding straw, which was used for making hats, but the majority of the population, including children, survived by working the land.

Strand was searching for what he referred to as the "essential character" of the people he encountered. He believed that if he were able to discover that element, he would arrive at a commonality that could relate to everyone. In his portraits of the Italian peasants he sought to represent all of humanity. Although he was attempting to be wholly objective by advocating a straight approach and allowing the people to tell their own stories, the reality was that his vision was highly subjective.

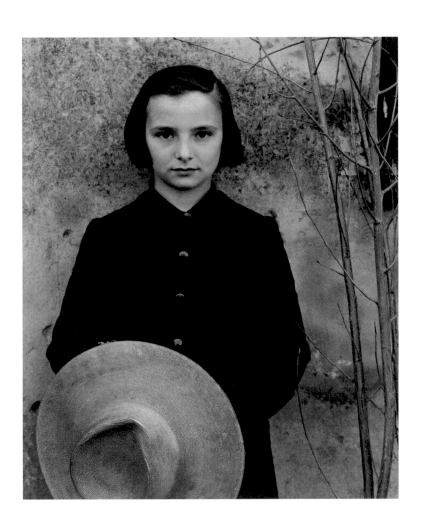

PLATE 40

**Grass,
Luzzara, Italy**
1953

Gelatin silver print
19.4 × 24.4 cm
(7⅝ × 9⅝ in.)
86.XM.683.38

In providing a complete visual record of
Luzzara and the surrounding areas, Strand
did not restrict himself to portraiture alone.
He photographed the buildings, streets,
Po River, woods, and even blades of grass,
as shown in this plate. His vision was
all-inclusive, and while his subjects were
diverse, they were always deliberately
chosen. Strand utilized a range of views to
create a sense of the place and enable
a rhythmic flow in the turning of the pages
of *Un paese*. Harking back to his cinema-
tography work of the 1930s and 1940s, he
was cognizant of the need to present
both overall views and detailed accounts.

Here, the grass appears flattened
by the rain, whose water droplets still cling
to the individual blades. It is almost as
if Strand has stripped everything away to
reveal the very core of Luzzara's existence:
the land. The work continues the nature
theme found in compositions he had made
at Georgetown Island, Maine, during the
1920s (see pls. 12–14) and also looks ahead
to the work he would do late in life, when
he photographed in detail his own garden at
Orgeval, France.

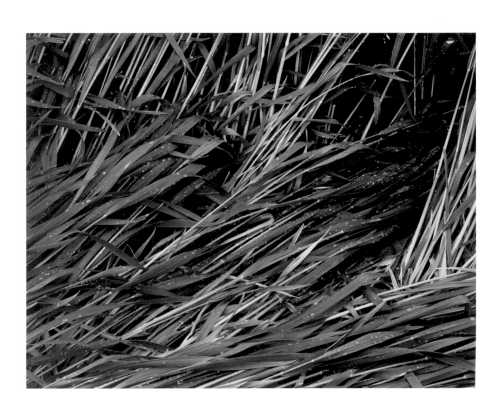

PLATE 41

Ox Yoke and Ropes, Luzzara, Italy

1953

Gelatin silver print
24.4 × 19.2 cm
(9⅝ × 7⁹⁄₁₆ in.)
86.XM.683.77

Since the 1920s all the communities Strand focused on were rural and agriculturally based. Despite his early work on the subject of city life in New York and subsequent interest in the machine age, Strand was primarily interested in documenting the life of the peasant, the worker, the common man. His photographs were always rooted in the idea of labor as the chief human virtue, even when not featuring the presence of any one individual. This still life of an ox yoke and ropes celebrates the actual tools of labor, which, as instruments, come to stand for the man and beast that work the soil. While many of the residents of Luzzara did not own any land, it played an important part in their lives: they worked on it, lived off it, and ultimately would come to rest in it.

Many of the texts that accompany the images in *Un paese* are firsthand accounts dealing with the harsh reality of living in a community that had managed to survive war, near-constant flooding from the Po River, and pestilence on agricultural crops. The photographs do not tell a modernizing story but commemorate the traditional, almost antiquated, ways of life. Although the reader is told that there are now more instances of cars and mopeds in the village, Strand never records these modernizing symbols. While Cesare Zavattini's words reveal the struggle, Strand's photographs present a heroic survival that speaks to a past rather than a future.

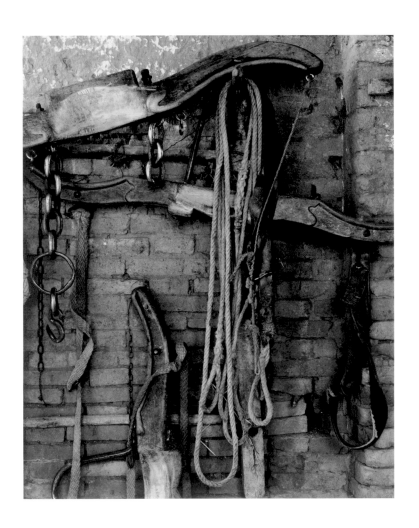

PLATE 42

Norman Douglas

1954

Gelatin silver print
14.6 × 11.4 cm
(5¾ × 4½ in.)
84.XP.208.51

PLATE 43

John Angus MacDonald

1954

Gelatin silver print
14.4 × 11.7 cm
(5¹¹⁄₁₆ × 4⅝ in.)
86.XM.683.45

PLATE 44

Kate Steele

1954

Gelatin silver print
14.8 × 11.7 cm
(5¹³⁄₁₆ × 4⅝ in.)
86.XM.683.39

By the time *Un paese* was published in 1955, Strand was already preparing his next book, based on the people of South Uist, in the Outer Hebrides of Scotland. After hearing a radio program on the Gaelic songs of the island, he wanted to find out more about this ancient culture and set off to spend three months getting to know the land and its inhabitants. The resulting book, *Tir a'Mhurain*, was published in 1962 with Strand's pictures accompanied by text from the cultural historian Basil Davidson (b. 1914). The pattern was now a familiar one—the writer retraced the steps of the photographer and, putting words to the images, revealed the lives and stories of the native islanders who had previously stood before Strand's camera.

The Scottish portraits, like the French and Italian ones before them, are heroic in nature. According to Strand, the individuals not only represent themselves but also are part of a culture that through its simple yet precarious existence was at risk of being shattered, or worse, eradicated through the pernicious impact of the modern world. When he made these photographs in 1954, the population of South Uist was fewer than four thousand; today the population has declined to just over two thousand, perhaps validating his underlying premise of a threatened community.

In these portraits Strand places each individual in the center of the composition, the sole subject set against the background of a weathered wall. The structure comes to symbolize the backdrop of life—an existence equally as rough as the stones themselves. A stabilizing force in Strand's execution of the image, this support offers a very practical element of an impromptu studio setting and functions as a common denominator. Whether in France, Italy, or Scotland, each wall is an appendage to the existence of the people featured in the photographs, individuals who represent the universal struggle of humanity.

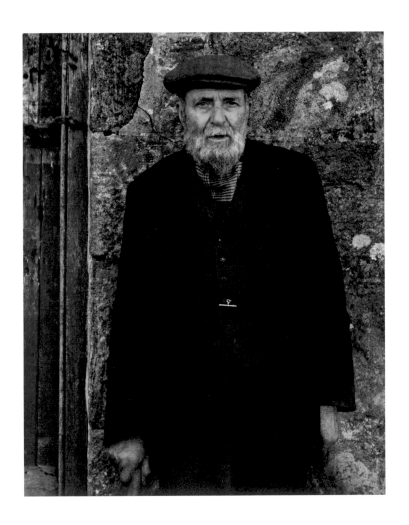

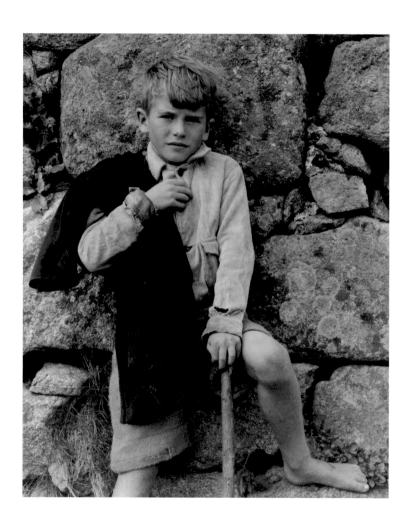

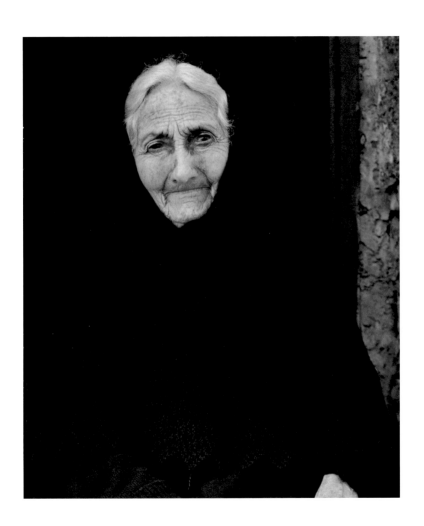

PLATE 45

South Uist, Scotland

1954

Gelatin silver print
14.8 × 11.7 cm
(5 ¹³/₁₆ × 4 ⅝ in.)
86.XM.683.49

The Outer Hebrides are a group of islands (including Benbecula, Eriskay, and South Uist) located off the west coast of Scotland, where even today the only means of access is via ferry boat. Strand always sought to record the vital components that made up a community, and his photograph of the MacBrayne ferry was an acknowledgment of the important role of sea transportation in the Hebrides. Rather than adopting a simple documentary approach, he constructed from the boat's elements—a series of riveted metal sheets and a cluster of mechanical equipment—a Modernist image of interlocking black-and-white forms.

In Strand's time the inhabitants of South Uist were a devout people who strongly adhered to keeping Sunday free of all work in order to encourage prayer and reflection. He was drawn to the ferry system by an apparent plan to introduce Sunday service. For many islanders this was considered a terrible fate, just one of many instances that were perceived as undermining their culture. Faced with a shrinking population—one that had been forcibly removed at certain points in history with the Highland Clearances—there was a very valid concern about the longevity of the Gaelic people and their traditions.

PLATE 46

**Fishing Gear,
South Uist, Scotland**

1954

Gelatin silver print
11.7 × 14.8 cm
(4⅝ × 5¹³⁄₁₆ in.)
86.XM.683.50

South Uist had a small population of local fishermen, whose livelihood was increasingly under threat from the large trawlers that came from mainland Scotland and England to fish for herring and lobster in the waters surrounding the Hebrides. In *Tìr a'Mhurain*, Basil Davidson's writings provide a historical overview of the situation while presenting a detailed account of the impact on the local community. Strand's photographs also touch on the subject indirectly.

In this image Strand looks down from his vantage point and captures the seemingly disparate elements of fishing gear. It is scattered across the deck of a boat in an abstract composition of shapes and textures. At the center is a pair of discarded rubber boots. Above them, a coiled rope creates a void that is countered by the volume of the buoy next to it. The picture can be read as a metaphor: the empty boots waiting to be filled are symbolic of the need to continue with traditions across generations in order to ensure the survival of the culture. The whole arrangement questions the presence (or absence) of the future generation, who will literally fill these boots and sustain the community.

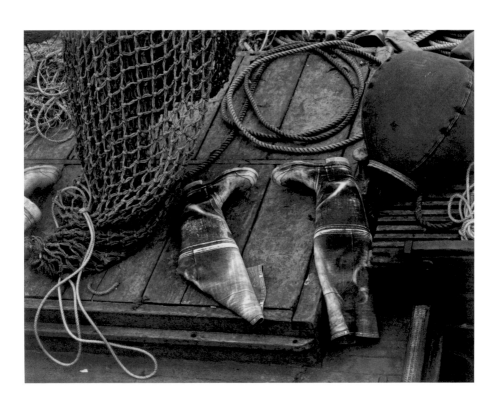

PLATE 47

White Horse,
South Uist, Scotland
1954

Gelatin silver print
11.7 × 14.8 cm
(4⁵⁄₈ × 5¹³⁄₁₆ in.)
86.XM.683.47

Throughout Strand's lengthy career there are several examples of horses within a landscape, such as plate 15 and here. As a working animal and form of transportation, the horse was a traditional feature in many of the rural communities Strand visited. Yet, as technology advanced and modern society encroached upon these regions, the horse was replaced by machinery (specifically tractors in South Uist) and literally put out to pasture.

The horse shown here on a barren hillside is positioned in such a way that it is turning its head toward the camera, creating an almost whimsical scene, as if beckoning the viewer into the remote setting. Symbolically, the white horse may represent inspiration, fertility, and peace— perhaps suggesting a pointed reference to plans for the construction of a missile-

launching facility on the island—Strand's interest in the inherent qualities of the black-and-white medium, or a past life, one that was slower moving, simpler, and nobler.

After *Tìr a'Mhurain*, Strand went on to create photographs and subsequent books based on his travels in Egypt and Ghana (subjects that are not represented in depth or at all in the present collection of the Getty Museum). Although the political climate gradually changed in his homeland, Strand never settled in America again, returning only for visits. His love for his country never failed, but neither did his politics and his belief in the spirit and humanity he found expressed in various communities around the world. From the 1950s onward Strand lived in Orgeval, France, where he would remain until his death in 1976.

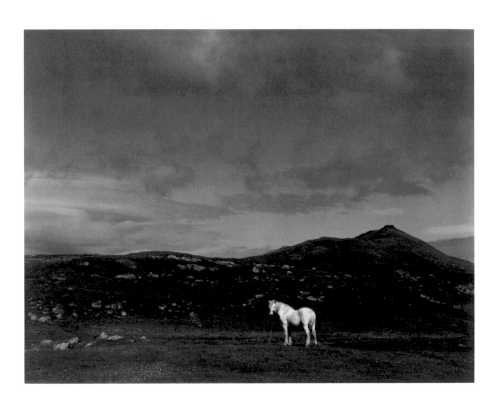

Hazel Kingsbury Strand (American, 1907–1982).
Hebrides [Paul Strand on Hebrides], 1954. Gelatin silver print, 9.4 × 8.7 cm
(3¹¹⁄₁₆ × 3⁷⁄₁₆ in.). © Paul Strand Archive, Aperture Foundation, Inc., Millerton, New York.
Paul Strand Collection, Center for Creative Photography, University of Arizona, Tucson.
The woman being photographed is Kate Steele (see pl. 44).

A Vital Spirit:
The Photographs of Paul Strand

David Featherstone: Paul Strand is one of the most influential American photographers of the twentieth century. Today we are going to look at a series of his pictures made between 1913 and 1954, a focus that reflects the holdings of the Getty Museum. Before we consider the first image, I'd like to ask Naomi to give us a brief introduction to Strand.

Naomi Rosenblum: Strand's career reflects the changes that took place in aesthetic and political ideas in the United States during the time that he lived and worked. I think his photographs can be divided into several distinct groups. In the beginning he conveyed ideas that Alfred Stieglitz had brought to photographic expression, especially the concept of vitalism as a necessary component of any kind of art expression. During this period he also was able to translate the new abstract forms that were appearing in European art into a photographic language. For the rest of his life his work reflected its basis in these two directions. I should add that, since he came from a liberal, humanist background—his education had been at the Ethical Culture School—that formed a third thread that fed into the way he looked at life and expression.

Around the late 1920s his direction changed to include a more political understanding of what was going on in the world, and he hoped to reflect that in his art by making it available to a large audience. He did that first in film, and later

he settled on publications as a way his work could be seen by this wider audience. He became less interested in individual images and more interested in books.

Alan Trachtenberg: Naomi made reference to the liberal humanism that is part of Strand's outlook and is associated with his studying at the Ethical Culture School. In that context, Lewis Hine seems to me to be a figure that we can't ignore, particularly if Strand's earliest photographic experience is connected with studying with Hine at the Ethical Culture School.

Anne M. Lyden: Later on, in writing to Stieglitz, Strand referred to Hine as his first photography teacher, so Strand was very much aware of the role Hine had played in his work.

NR: I don't believe Strand thought that he was very influenced by Hine. I asked Strand that on a number of occasions. In the early 1970s, late in his life, he said that Hine didn't understand what he was trying to do. So I think the idea that Hine had a very strong influence on his work is probably not so.

AT: The question of influence isn't really the question that we're confronting, but rather the question of Hine's importance early in Strand's career as a conveyor of ideas of photography. What I'm suggesting is that Strand was exposed to a certain practice of photography that he did not pursue. In light of his further development toward a certain politics, that is an interesting observation and not to be ignored.

Mark Ruwedel: This puts Strand in an interesting position for me, as a teacher, because Hine and Stieglitz are like matter and antimatter in terms of the way photography is often presented in university courses. For somebody to be bouncing back and forth between those poles in following their own trajectory is fascinating.

DF: The first photograph we're going to look at today (pl. 1) is a platinum print made in 1913, just a few years after Strand's studies at the Ethical Culture School.

Weston Naef: Our cataloguing records indicate that this picture has been published with the title *New York*. It represents a very soft-focus pastoral landscape that seems to be a pure manifestation of an issue that was being written about in *Camera Work* in 1910 and 1911, where it was stated, I think by Sadakichi Hartmann,

that art must first be a pure expression of personal feeling, and second, that a work of art must not represent the world but exist as an aesthetic object separate from it and equivalent to natural objects.

NR: This picture doesn't look like New York to me, because there's no lake in Central Park without buildings behind it. It looks to me like a pastoral idyllic image from either the shoreline of Long Island—which I'm not sure about either, because something about the land doesn't suggest it—or Twin Lakes, Connecticut. The Strands summered there for many years.

WN: The date of 1913 seems to be secure, and that means this was made after his six-week trip to Europe in 1911. Are any photographs surviving from that European trip? In some ways, this seems to represent a European viewpoint not only of how to make a picture but also of what to photograph.

NR: There are pictures from Europe that are very similar to this. One, of the Neckar River in Germany, has trees on the edge of the water, and it's soft focus in the same way. Strand called these "Whistlerian impressionist pictures," in which the soft focus would "mushify"—that was his word—the entire thing. But it pulled the composition together, which is what he said he was trying to learn to do at the time.

DF: Do you see any continuity between this and Strand's later work?

AL: You could argue tangentially yes, in the sense that he's looking to the real world around him. But he came to reject this Pictorialist style and saw it as an over-simplification. This doesn't necessarily connect to the late work, but it's a starting point. As a young photographer, he was trying to find his own vision. Up until this time, all the photography he had been exposed to had been in this tradition.

AT: In 1913, how did he think of himself in regard to following the vocation of photography? Had he committed himself?

AL: According to his army records, he considered himself a working photographer beginning in 1911.

NR: In 1912 he started a business photographing on college campuses and trying to sell those pictures. Many of them have this same soft look.

I think what he was trying to do here was to organize a pictorial surface, to find a place to stand where nothing would fall off the edges of the picture—which is something he was very clear about—and where interest would be kept inside the picture by the forms. That's what the problem was for him here, and that's what the soft style helped him with.

WN: Let's remember that Strand was only twenty-three years old. He had been to Europe and back, so I think we have to look to Europe as the source of inspiration for him here, in artists like Heinrich Kühn and the work that Steichen did when he was in Paris from 1900 to 1902. Clearly, Strand was influenced by what he would have seen reproduced in issues of *Camera Work* from five years earlier that we know he owned.

AL: Strand had already visited the Photo-Secession galleries. He went with Hine as part of the class visit from the Ethical Culture School in 1907, and that's when he saw works by Frank Eugene, Gertrude Käsebier, Clarence White, and Stieglitz.

AT: In my mind, the word *Pictorialist* is not the adequate account of this image. Pictorialism has to do with the notion that a photograph can be a picture, and not simply a photograph, that is, not simply a trace of the visible world as it's produced automatically by the lens. I don't think that Strand ever ceases to be Pictorial in that regard. His great strength lies in the fact that he is interested in picturing the world rather than simply reproducing it. So the interest that this image presents is one of Strand showing his commitment to the making of pictures.

NR: Even so, this shows an early, almost studentlike, way of Strand finding his path into photography. It is not a particularly strong example of what he eventually was able to do in giving both natural and manufactured forms a sense of inner life. I don't think this has a great deal of inner life.

DF: Let's move on to the next picture, which has a great deal of inner life. Done just two years later, in 1915, its title is *City Hall Park, New York* (pl. 2). Can some-one define the vitalism in this?

AT: I think the concept of vitalism may need one or two additional descriptive statements. The first principle of vitalism is that all is flux—things are always

changing. The second principle is that things in both the natural and the human world are moving. In their process of change, they are moving toward a moment of crystallization, or self-expression. Now, *crystallization* is not a good term, because it implies a fixity. Moving toward many moments of self-expression would be better. When all the elements within the object—or, in this case, in the scene— have achieved a relationship, it is expressive of the whole, the entirety.

I think this picture is a superb example of that. This is certainly an image that is not set up, not staged by the artist, but instead a sign of the artist being prepared to accept the given nature of the world.

AL: But what is interesting is that Strand altered this image. He removed a figure from the foreground. If you look in the lower portion of the frame (see p. 104), there is a shadow of a missing person. Strand went into the negative and removed the figure. Here he is championing the objectivity of going out into the world and capturing what is there, and yet he has no compunction about fussing with it.

WN: This picture is extraordinary. I don't think that any photographer before Strand had so successfully brought together within a single image so many aspects of American urban life. The crowds, the interplay of different social classes, and with architecture as a backdrop. That's the unifying aspect that I think is so powerful here.

AL: This photograph has a wonderful elongated composition where there is a difficulty in reading perspective as we are traditionally used to seeing it. It's like a Japanese scroll.

NR: The S curves he has worked out are repeated by the railings, and then he found a tree that repeats the shape in the upper right-hand corner. That gives this picture movement. Think of what it takes to see all those curved forms in one moment, the railings and the shadows of the trees and the way the people move through the space.

AT: Right. It's what makes this image so strong. You might even say it's what makes this a great pictorial photograph. I could suggest ways in which the image also reveals limitations in the short term, because from a vitalist point of view, the human beings are transformed into integers in a form. That's to say, their subjec-

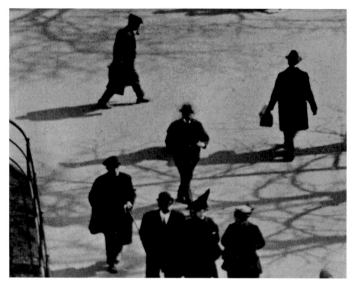

Paul Strand.
City Hall Park, New York, 1915 (pl. 2, detail).

tivity is lost. Their individuality is gone. There's no encounter with them. What we encounter is a pattern.

MR: To use Strand's words, I think this is a Whistlerian picture. For me, this is a much more interesting image in terms of the Japanese influence through painting to photography than *New York*, which is more like a fake painting. This applies Pictorial lessons in a far more interesting way.

I agree with what Alan said about the loss of individuality. This is a picture about patterns, not about individuals. I'm sure one could surmise certain things about the time by looking at hats and other clues, but it's really not about those people as subjects.

DF: The next picture, which Strand simply titled *Photograph* (pl. 4), is from 1916 and introduces another aspect of his early explorations.

WN: *City Hall Park* is almost 13½ inches tall, which is quite a big print, and this one is about 10 by 11 inches. These are photographs designed to go on the wall. He

enlarged the negative in order to achieve this scale, so Pictorialism is still really a driving force.

AT: Strand was producing these pictures for spaces devoted to the exhibition of art objects. Behind the format of this image, and the last one, is Stieglitz's 291. That was a uniquely modern institution that gave birth to the idea of an exhibition space for photographs, on the analogy to modern paintings.

WN: This is a still life, the French *nature morte*, something dead, yet I've always thought of this Strand picture and ones like it as having a vivifying force that comes from the use of light. He is a master at harnessing the elements of photography that record light. He does it in such an incredibly precise way that it enlivens the image.

MR: In fact, the lighting here is really antithetical to the still-life tradition of painting. It's harsh and one-directional. What the lighting does in this image is to make the shadows as substantial as the objects. In the top right quadrant, that dark shape behind where the two bowls meet is a very provocative curved form that is more of an object than the inside of that bowl. My sense is that he's using a direct, nondiffused, single-point light source—I don't know whether it's an electric bulb or the sun. It's a very sophisticated image pictorially, but at the same time, because of the lighting, it seems kind of crude.

NR: I think it was done outside, on the porch of the house in Twin Lakes. I'm not sure that house had electric light. Strand would tell people he preferred natural light, but he also said he was not interested in lighting as such, that he didn't think about lighting.

MR: But that's what he's thinking about here. It's the tool he's using to make the picture. Where the light source is and how it's modulating the objects remains the same whether it's a light bulb or the sun.

AT: Thematically, you could also say he's thinking about nature—the pear—against the artifacts of manufacturing, and he put those together with the light creating an insubstantial substance, the shadows.

WN: So this picture speaks to me of reconciling dark and light, the natural and the man-made.

AL: I don't know if he's reconciling or just experimenting. It seems like he's playing around, and the light is creating shapes and forms that he is seeking to compose within the frame. I see this picture as somewhat experimental; I don't think he's really arrived where he wants to be.

DF: *Photograph—New York* (pl. 7) is one of Strand's best-known pictures. The negative is from 1916, and this print is a photogravure from the final issue of *Camera Work*.

AL: The issue of *Camera Work* that this is from combined numbers 49 and 50 and was published in June 1917. It featured eleven of Strand's images reproduced as photogravures. It also included his essay on photography, which he had originally written for the *Seven Arts*.

WN: The number of subscribers to *Camera Work* had dwindled from about thirteen hundred to three hundred in 1917. Since the number of copies printed was getting smaller and smaller, the overall quality of the gravures was actually increasing, because fewer prints were being made from the copper plates. When you look at this piece beside the platinum prints we've examined so far, it has an extraordinary presence. The photogravure process achieved nearly continuous tone by translating the photographic image onto a copper plate that was acid etched, coated with printer's ink, and put through a traditional etching press. The ink pressed from the plate onto the Japanese tissue yielded an incredibly luminous image. Stieglitz and Strand were very aware of the power of this tool of reproducibility and the power of sharing pictures with a wider audience.

MR: My suspicion is that the sign is slightly exaggerated through the gravure process to make the tonal relationship even brighter than it would have been in that lighting situation. It's very easy to do that, working on the plate.

DF: The Strand issue came at the end of *Camera Work*'s run as an important publication, and he was just twenty-seven years old when it was published. Did he say anything at the time that expressed what he felt about having this issue dedicated to him?

AL: A lot of his letters to Stieglitz at the time focused on the ending of 291 and the fact that this was the last *Camera Work* issue. It was almost as if Strand were trying to encourage Stieglitz to stay strong and continue the fight.

NR: But he also took *Camera Work* with him when he went into the army, and he showed it to his fellow soldiers. He was obviously very proud of it, and he wrote that he was able to convince them of the importance photography had. There's no question that he felt very rewarded by having been published in *Camera Work*.

AT: Several of the companion *Camera Work* images are also street portraits, showing individuals with highly selective but revealing fragments of the city, like the stone wall here. But this image really leaps out as the seminal one.

DF: Is it correct that he used a dummy lens on his camera so he could photograph without being noticed?

AL: Yes. He had a brass lens from his uncle's camera that he fitted to one side of his camera. The dummy lens would point forward, and his real lens would be coming out from under his left arm. This allowed him to take these pictures without the people necessarily being aware of it.

NR: People were very resentful of the new handheld cameras of the time invading their privacy. Strand wanted to be able to make these images without having that onus of sticking cameras in people's faces. He didn't feel that the subterfuge was dishonest, he just felt that the person should not be annoyed by the photographer.

Alan mentioned this being from a group of street images. Whatever Strand got from Hine and from his liberal-humanist education drove him to portray lower-class people in the streets. It was a decision, I think, that arose from that configuration of beliefs that came with being educated in a certain way and being from a certain kind of liberal background. His aunt, for instance, was the first kindergarten teacher in New York.

AL: Remember, too, that this is 1917, and in April of that year America had entered into the war in Europe. When I look at his choice of subjects—the lower class, the infirm—I can't help thinking that he was making a conscious connection between those who were suffering in Europe and those who were on the periphery of society in New York.

AT: Whether he wishes to avoid arousing resentment in the subject by using a fake lens or wishes to achieve the illusion of complete spontaneity—not allowing the subject's awareness to interfere with the transparency he wanted to achieve—it seems to me that what is involved is something that has to do with visibility.

This image, which foregrounds the question of visibility with its great sign, let alone the eyes, seems to me to be a new kind of picture, one that probably hadn't existed before in quite the same way, certainly not with this level of self-consciousness. I use that term, because when you put this photograph together with the others, you realize that Strand knew what he was doing. In effect, people were walking by these subjects and not seeing them. In these pictures Strand was attempting deliberately and powerfully to bring what is socially invisible into visibility. It's what Hine set out to do, in a different kind of picture, but it's the same thing.

NR: The stone wall interests me, because so many of the portraits have amorphous backgrounds where you can't tell what's going on. But this one was part of the Armory on Park Avenue between 33rd and 34th Streets. The stone has a feeling of rough New York that few of the other backgrounds have.

MR: I think some of the immediacy of this picture comes from the fact that the background seems to not have been considered in making the image. In many of his portraits you can see how careful he was to have things on the edge, or parallel lines just within the frame. This seems askew, and the three vertical joints between the stones don't do much pictorially.

WN: What you're saying is that by tilting the camera slightly, he could have made the vertical lines vertical.

AT: We can't leave this picture without asking why Walker Evans responded so powerfully to it.

WN: Yes. What was the context of Evans's encounter?

AT: Evans was a young man just back from Paris, where he took up photography. In 1928–29 he was working in the New York Public Library, and he picked up *Camera Work*. After he saw this picture, he wrote to a close friend that it leaped out at him and showed him everything that he wanted to do in photography.

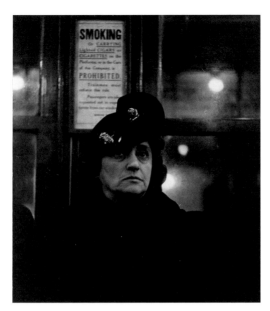

Walker Evans (American, 1903–1975).
Subway Portrait, 1938–41. Gelatin silver print,
12.7 × 11 cm (5 × 4⁵⁄₁₆ in.). 84.XM.956.703.

AL: And of course, this came to fruition in Evans's subway portraits, when he used a hidden camera to record the unwitting passengers (see above).

MR: What I first knew of Strand came through my interest in Evans, so this connection is really important to me. I know that Evans referred to Strand's photograph in interviews, so there are probably several versions of what he said. I've heard that he saw it and commented, "There, that's the stuff." But he also said that this was the only picture in all the issues of *Camera Work* that was of any interest at all. This is also interesting in light of Hine, because there's no sentiment in this picture, in the way that Hine used it. There's no attempt to portray this woman as a contemporary Madonna; there's no angelic light coming down as in some of Hine's Ellis Island pictures. It's very harsh, and not just in the printing. It's a hard look.

AL: I think with Hine there was always a context, so you really have a sense of where a particular person happened to be in their life. But with a Strand portrait

from this period, he was focusing on the person and his or her visage as if he were trying to capture something of the psyche. It's completely irrelevant where they are in their life, whether they're in New York or somewhere else.

NR: I don't think so. I think it's important that most of them are from New York. He did a few portraits in Twin Lakes that are quite different.

AT: I don't think this is a portrait.

NR: Really? You don't think it's a portrait?

AT: No, not in the usual sense. I think this is a picture about the impossibility of knowing the world. I think the blindness is not only that of the woman but also that of the viewer. There's no way of getting inside this woman. She is identified by her blindness. Not only is the picture without sentimentality, it's without sentiment, which is to say it has no feeling at all. There's no compassion. There's no pity. There's sheer acceptance. It's the most utterly existential image that one can imagine—this is the way it is. That's what I think Evans responded to.

DF: The next photograph we're going to consider is *Rebecca* (pl. 10), a platinum print from 1923. Naomi, please tell us about Rebecca.

NR: Rebecca Salsbury was a younger classmate at the Ethical Culture School whom Strand may or may not have known while there. He was reintroduced to her because she was head of a committee that did something for the alumni. He met her again and took up with her, but this was after his attempt to get Georgia O'Keeffe interested in him. And O'Keeffe actually was interested in him briefly, but I think she probably felt her chances with Stieglitz were more solid than with Strand, who was not really a functioning photographer at that time. Rebecca had also been very enamored of Stieglitz, although I don't think they ever had the affair that some authors have written about.

WN: I've always assumed, even though we can't see the rest of her body, that she is nude here.

AT: Are there nudes of Rebecca by Strand that are known?

WN: Yes, but he didn't want any of the Rebecca pictures shown.

110

NR: Strand married Rebecca in 1922, and he proceeded to make this series of photographs that followed what Stieglitz was doing with O'Keeffe. There seems to have been a great interest in these, but Strand was upset about that interest. He felt that what he had done was to mimic Stieglitz's O'Keeffe pictures.

AL: Did he feel that, or did Stieglitz feel that he was doing that?

NR: Strand felt that, and perhaps Stieglitz did too. Strand put these pictures away and would not show them for many years, until the end of his life, when everything became, shall we say, an object that he could sell. I think it was also compounded by the fact that their marriage broke up, and he was even less interested in revealing anything he felt about her. He was so hurt by what happened that he buried this picture and the others. The photographs Strand made of her always have some element of tension, suggesting that their relationship was problematic. This one is less so, but there's still a quality of uneasiness.

AL: As much as she's engaging your view, at the same time there's something challenging about it. She's letting you see her, but you're not getting much further than that. I agree with Naomi, there is a tension in all Strand's portraits of Rebecca, almost as if there's an unspoken issue present. He wrote about her a lot in his letters, and there are all these photographs of her, but in my reading of them there is very little sense of any true affection that comes through in either. It may be that I'm making too great a comparison to Stieglitz's prolific body of work with O'Keeffe, where there is a very palpable sense of the connection between two individuals. With them, a strong emotional content comes through that I never get with Strand's Rebecca portraits.

WN: O'Keeffe by Stieglitz is a chronicle of a powerful, libidinous, erotic relationship that is undisguised. Whereas we see through Strand's photographs evidence of a different kind of relationship between Strand and Rebecca. There are no pictures that to my eye probe the inner sanctum of their relationship.

AT: Why don't we just take this as a picture on its own terms? The face lying there is almost Ezra Pound's image, in an early poem: "The apparition of these faces in the crowd; / Petals on a wet, black bough." She's lying there like a helpless thing, and her eyes suggest to me that she doesn't know what she's doing there.

NR: That's the distance that we've been talking about, that she's not involved in this.

AT: But you're talking about Rebecca and Strand. I'm talking about the picture.

NR: Well, there's a connection. There has to be!

AT: If you tell me the connection, we can write it up and it becomes a narrative. It could be fiction, it could be autobiography—I don't know. I read recently about a lecture that Strand gave in Chicago, late in his life I think, in which he spoke about all pictures implying a text, and groups of pictures implying text that would hold a group together and explain what they have in common. But the text that any picture implies can't be definitive; if it were, I think it would be far less interesting.

DF: The photograph *Lathe #1, Akeley Machine Shop, New York,* from 1923 (pl. 11), a gelatin silver print, is a very different kind of image. Ironically, Strand seems more engaged here.

NR: Strand had purchased an Akeley movie camera in order to earn a living as a cameraman. When he got out of the army, he felt that he could make medical films. This did not pan out, but he did use the Akeley for a variety of motion pictures. The purchase was made possible in part by Rebecca and in part by an inheritance from a well-to-do uncle. Strand created still photographs of the Akeley camera first and was very interested in the configurations of the instrument. On occasion he had to have it repaired, and he made about eighteen images in the Akeley machine shop of lathes, drill presses, and so forth.

WN: I think this is a watershed image for a variety of reasons, one of which is that up to this point—to *Rebecca*—Strand had been ahead of his time. He made pictures that had not been seen before. We've established that *Rebecca* is slightly derivative of Stieglitz. The question I have is whether *Lathe #1* is ahead of its time, considering that by 1915 Francis Picabia and, to a lesser extent, Marcel Duchamp, who were both highly influential on Strand, had begun to incorporate machine parts and mechanical associations into their creations. The question I'm asking is whether Strand is doing something here that employs the fidelity of the camera in the most appropriate possible way—using the process of photography to record elements that were unsatisfactorily realized by Picabia and Duchamp, and therefore advancing

significantly ideas that they proposed—or is he, in fact, treading water in a way that may be similar to the Rebecca pictures?

AT: The first thing I would say about this picture is that its being such a close-up suggests that Strand was exploring other possibilities as a result of his experience with the movie camera, such as moving in close.

WN: So you can say he is doing something experimental in this picture by moving in so close.

AL: He is and he isn't. I think that you have to refer to the work he's done thus far and to the work he does in the future. It all fits into a common pattern of doing close-up exploration, an abstract study of shapes and forms, in the same way that he did with the bowls and pear and with other forms later on. Those themes obviously occupied him throughout his life; it's just that the subject changes.

MR: This represents a different idea about making pictures than the bowls. In this shop with his camera, he was moving the camera around. With the bowls, he was moving them around. I find that this picture is much more descriptive. My interest is more about what the machine actually does, or the potential of what it can do. It's designed for a task.

NR: But this is not a working machine. Anybody who's ever operated a lathe understands that what comes out of it is oil and little squiggles of metal, all over everything. It's the messiest thing you ever saw.

WN: That's an important point, because Albert Renger-Patzsch, at about the same time, was going into machine shops and factories in Germany and photographing the messy manufacturing processes. His images are the opposite of Strand's pictures of the pristine Akeley works.

AT: This is also painterly. This was the time of the Precisionist movement in American painting.

WN: It's an archetypal Precisionist image. Naomi, do we know whether the machinist kept his tools like this?

NR: The Akeley machine shop had existed for a while, so it must have been cleaned up by someone. I'm sure it wasn't Strand. None of the machines in all the images—the milling machines, the drill presses—have any mess about them at all. These are idealized machines, so he's trying to say something about this machinery.

AT: Well, you could say that the picture focuses on an asocial view of mechanical power, and being asocial, it's taken out of a context where any discussion of responsibility or ethics would be appropriate. The picture says that machines are pure, clean, powerful, and that's all. There's no indication that they are productive or part of a productive system.

WN: Or that they're operating.

NR: That's right. As Hine said, it's not the machine, but the man behind the machine that makes society work.

AT: Mentioning Hine, of course, brings to mind that, around this time, he was also doing pictures focusing on men and machines.

NR: Yes, but I'm not sure Strand saw any of those. I would rather doubt it. In a way, Strand is more prescient about the future than Hine was. Hine felt men and machines were locked together, and that we needed the human being to run the machine. Strand was saying no, it's the machine.

DF: *White Shed, Fox River, Gaspé*, from 1929 (pl. 16), is a small platinum print. Gaspé is a region of Quebec, Canada, along the St. Lawrence River.

NR: Strand went to Gaspé in September 1929 after spending part of the summer in Lake George, New York. In 1975 he told me that he didn't make portraits the first time he was in Gaspé. He said: "[I] was concentrating on [the] problem of landscape—first time I really tackled [the] problem of landscape instead of nature close-up. . . . I am not good at trying to do too many things at once, for example, in 1914–1915, I did abstractions to the exclusion of anything else. In [the] same way, in 1929 I felt I had to work out [the] problems of landscape." He used to tell students that they should look at the El Greco painting of the storm over Toledo in the Metropolitan Museum of Art, because they would see the optimal solution of how to get ground and sky to relate.

WN: Here we really do get the sky. But this dominating early morning or late afternoon light coming off the clapboards of that very geometric building does somehow call to mind the cathedral in El Greco's painting. This is a very formalist picture that is dependent for its success on the relationships between all the triangles.

MR: This is the first print in our sequence that's very small. That miniaturization is part of what contributes to the formalist reading Weston mentioned. We're not so interested in the construction of the barn in this picture, because we barely see that information. It's really a picture about light, and that relationship of the ground to sky is made by light.

NR: Do you think he was reacting to the Stieglitz cloud images here?

WN: That connection cannot be underestimated, because 1927 to 1929 was the peak of Stieglitz's involvement with the *Equivalents*. I think we need to explore the question of whether Strand is trying to create another kind of equivalent here. Is he seeing in the structural forms and the light coming off those buildings something that is an equivalent? We are viewing here something so completely grounded in reality that we can't decide whether it's an abstraction or something real. I see here a direct confrontation with the concept of the equivalent that Stieglitz articulated.

NR: I think you're right about seeing this as a balance between an abstraction of form and reality. There's a sense of the reality of life embedded in these structures. It's possible that he was reacting to the *Equivalents*, because Stieglitz said that you could read anything you wanted into them. But I don't think Strand intended that for this kind of picture.

AT: There are two things about it that strike me. One is that the photograph counts on perspective—the point of view of the camera—in an exquisite way. The central objects are slightly off center, not symmetrical. The point of view is slightly from the side, which gives you a sense of an object that contains a volume not visible to us. There is a sense that the black form is an opening to something that contains dimensions of its own.

WN: I see that completely. The miracle of the picture is in the way the shadow on the left side of the roof gives volume to a shape that is essentially flat. It shouldn't be,

but the three-dimensional buildings look flat and dimensional at the same time. That's the exciting thing for me. Going back to a word that we used at the beginning of our conversation, *vitalism*, here he vitalizes the picture by harnessing light.

AT: The second thing that strikes me is that the picture is the construction of an entirety, including the clouds. That is, he's putting things together in relationship to convey a sense—and this is where equivalence comes in—of wholeness, of an organic interrelationship of elements that are also forces. This leads to the focus on the clouds, because they are the least stationary element in the picture. The light is more responsible for shaping our perception of the clouds than is the case with the man-made objects.

This picture, more than any other we've seen so far, really condenses space and time into a single image. I'll stress again that I think the point of view is extremely important. What constructs this image is not the actual objects as they are, but rather the perspective from which they are seen.

DF: So are these the problems of landscape that he mentioned to Naomi?

AT: It may be what he meant by the problems of landscape, but I think they're problems of perception.

MR: This one is a lot more calculated in terms of camera work. This is a picture that could only be made with a view camera. He is standing slightly off center, which means he is looking at it from a slightly oblique angle. Nonetheless, the horizontal lines in the picture are parallel to the picture plane, which means he's manipulated the front and back of the camera, the front for focus and the back for perspective. That's what allows the flat, collagelike look simultaneously with some sense of depth.

DF: Let's carry that idea into the next picture, *Rancho de Taos Church, New Mexico* (pl. 19), which I think has a lot of similar things going on. This is a platinum print from 1931.

WN: I knew this place through Strand's pictures before I ever stood there myself. What I remember most vividly is the oddly shaped buttress that comes off the side of the church.

AT: The relationship between the construction and the ground is very vivid and profound here. There is a real sense of solidity. Compared to the last picture, the clouds in the background are much diminished in compositional force. We're much more taken with how strong this structure is.

AL: Since he filled the entire frame with the structure, it seems that the clouds are secondary. They're not meant to be integrated in the way that they are in *White Shed*.

NR: But I think the clouds are important here, even though they're smaller. Essentially he did the same thing here as in the last picture, but it's a somewhat simpler image. There is a little strip of white on the right side, a very careful arrangement of the planes, and a sense that this is a dimensional object that exists in space. He's just taken it a step in another direction.

AT: I want to ask a question about the two pictures, which are both beautifully constructed and very satisfying to the eye. What is it that we learn from them about the way of life they represent?

WN: They are certainly archetypal of two very different ways of life. Both of them are governed by forces of nature: one by the powerful sea, and the other by a somewhat hostile expanse of land. They are two very different types of structures governed by the places where they are built, which takes us into the role of place in Strand's art. He was driven to relate the look of a place to the people who come from that place. We don't need to see the inhabitants here, because the building tells us everything we need to know about the hardships of surviving in this location.

AL: The similarity that interests me is that both are not New York. It is the 1930s, at the time of the Depression, and he left the city. Is this escapism on his part? Was he trying to go back to a simpler way of life, as found in Gaspé or here in New Mexico, because the modern world in New York had fallen apart?

NR: I don't think Strand was so much aware of the Depression in New York, because he never wrote or said much about it. But he did write about something happening in the countryside after being in New Mexico.

AL: How could he not be aware of it in New York?

NR: I meant aware in the sense of expressing his feeling about it. I think he did escape from it, but not in a personal sense. There were many factors. Rebecca wanted to be in the West, and Georgia O'Keeffe was there. He also wanted to get out of the movie business he'd been in. But he never wrote or said anything about the Depression, about the breadlines and the poor people in New York.

AT: Does it make any sense to say that, in this picture and the previous one, Strand is not looking to re-create the point of view of the inhabitants, but instead is creating a point of view of his own? This perception is not one that we feel belongs to those who use this church. It's a perception that belongs to somebody who comes from the outside and is able to see it in somewhat abstract, formalist terms.

WN: Starting with the Gaspé pictures, Strand went from New York to somewhat isolated places that he observed as an outsider. He *was* an outsider, and in some ways also a wanderer.

AT: He really began that in New York City.

NR: Alan makes an interesting point about Strand looking at this building in a different way than the people who lived in the area. What proves that is the fact that he insisted on removing a basketball stanchion that had been put up on this church so the kids of the neighborhood could play. That ruined his idea of the picture, so he got someone to tell the priest to take it down.

AT: In the 1930s, and this has something to do with the dislocation in the entire society, there was a quest on the part of photographers to use the camera, or the instrumentality of photography, to make discoveries of vital personal interest.

NR: American photographers, though—American discoveries.

AT: But not just the discovery of America—the discovery of their connection with what they would identify as American. The camera was an extremely important instrument in the making of personal identities. This is as true for Strand, who found personal revelations in such a picture, as it was for Walker Evans, who had an entirely different idea of what he was after photographically. But in both cases, it's a matter of connectedness. The camera is an instrument of connecting with something that you are not intrinsically related to.

NR: But isn't this also part of the movement among artists who came back from Europe and concerned themselves with native culture and buildings?

AT: These were all figures who felt dislocated in relation to America; that's why America was such a big theme for them.

NR: But it wasn't in the 1920s, after the war, but because of the Depression?

AT: That's what I'm saying. It's a dislocation, the rupture with an earlier idea and earlier social forms. Evans found something in the South equivalent to what Strand and others found in the Southwest. The important point here, from the point of view of a cultural historian, is that photography became a means for connecting, for identifying.

DF: That's a good segue into the next photograph, which shows a figure of Christ (pl. 24). It was done in Mexico in 1933.

NR: I thought this was an important image to include in our discussion. It seems to me that it has a relation to Strand's personal distress at the time, to the fact that his marriage had broken up and that the country he had come from was falling apart. He made a series of images of artifacts like this one, which were created after the Catholics arrived from Spain. Three of them were later included in his Mexican portfolio, although this one wasn't. They are real images of suffering, the most overt ones he had made up to that point.

AT: They are images of the transformation of suffering into art. This is a beautiful object. I'm sure he was drawn to the beauty of the transfiguration of suffering.

NR: I don't think suffering as such interested him, because he never really did images of people suffering directly. It's the transformation that he found of interest. Although some of the people he photographed in Mexico express suffering, they didn't know they were being photographed—he used a prism on the lens. There is not a happy image in the Mexican portfolio. There are no images where you feel joyousness; the vitality has taken another direction.

AT: You don't see any joy here?

NR: Do you see joy in this?

AT: I think it's an exalting image.

WN: I understand what Alan is saying, but rather than *joy*, I would use the word *ecstasy*. This has to do with the interaction of beauty and truth. The Cristos that Strand photographed, in keeping with the style of that genre, all have incredibly realistic elements—dripping blood coming down the shoulder, actual hair on the head, the real crown of thorns, leather thongs binding the hands, the ribs showing on the surface. The sculptors were trying to be faithful to some imagined reality that nevertheless remains fiction. Strand has transformed that preexisting fiction, which is meant to represent truth, into an equivalent, which is the photograph.

NR: What interests me is the little heart hanging from the hand. I don't think that's an accident. This was done right after a dreadful separation, not only from Stieglitz but also from Rebecca. So Strand was doubly personally affected. He was cut off from his roots here; he was in a brand-new place, trying to start something else. And he had a new political ideology that he was beginning to adhere to about the way the world is organized. It was a moment of crisis for him, and the heart, to me, is the central part of the picture.

AL: We should mention that, while he was in Mexico, Strand was also working on a motion picture, *The Wave.*

NR: In 1932, Strand, along with an anthropologist named Susan Ramsdall and her son, drove to Mexico City after getting the Mexican composer Carlos Chávez to arrange the papers that would get them into Mexico without too much difficulty. While Chávez was trying to get Strand to start a film there, he gave him a job of collecting children's artwork. He sent his nephew, Agustín Velásquez Chávez, to accompany him, because Strand didn't really speak Spanish well. There was an exhibition of the work Strand collected, and he made a report about what children in Mexico did and general culture in Mexico. Ultimately, the Secretariat of Education employed him to make a film in Alvarado, which is on the east coast just south of Veracruz.

AL: It's interesting that, in his work with the children, there is a connection to his own education at the Ethical Culture School. He was promoting the idea that the success of their education lay in their ability to practice art and to learn in a pragmatic fashion, the same way he had been taught at the Ethical Culture School. He

was becoming more and more political, and he was seeing art as a political force within society. I think the personal and political changes in him were becoming more and more identifiable.

NR: He had expressed his political ideas at the time. In a letter to Kurt and Isabel Baasch in November 1933 Strand said, "I don't know whether I can be labeled a Communist, but I find the ideas of Marx which I have been reading, very true to me—an ideal to be sure far distant even in Russia, but the only one left that has any hope in it for a decent human life."

DF: As we move on to the next image, *Apple Tree—Full Bloom* (pl. 31), we also jump more than a decade forward in time, from 1933 to 1947. What was Strand doing during this period?

NR: He was making movies again, but of a different kind. From the 1920s until the early 1930s he had made commercial films of various types. As we just said, in 1933 he was working on *The Wave* but left Mexico before it was finished.

Strand came back to the United States at the end of 1934, and Cheryl Crawford and Harold Clurman asked him to go to the Soviet Union, which he did in 1935. He carried sixteen pieces of luggage—all his equipment, all his cameras—and went to try to work with Eisenstein. When he got there, he discovered that that wasn't going to be possible, so he turned around and came back, stopping in England on his way home.

AL: Is it correct that he didn't make any photographs?

NR: He said he didn't make a single photograph while he was in Russia. When he came back to New York, he was asked to be the cameraman on *The Plow That Broke the Plains.* He, Leo Hurwitz, and Ralph Steiner went out west together to do the film. Strand went on to make movies for the war effort, then went to Hollywood, where he had some jobs. Eventually he returned to New York and became part of the group called Frontier Films. The motion pictures Strand worked on in Mexico and at Frontier Films are extremely important, because they planted the idea for the books that came later. When he found he could no longer finance his films, the books became his method of making movies out of stills.

AL: He talks about how, in his approach to still photography, he looked to film-making—how you need to have a balance between the long shot, the panoramic, and the close-up, and how it's through sequencing these that you get a successful film. He thought it was the same with photographs in books. You can't be repetitious with just one type of picture; you have to have a subtle balance to lead the viewer into the subject.

NR: He also found narrative to be very important. He would say, for example, that if you went someplace to make a story where horses were important, but you didn't like horses, you couldn't leave them out. He became conscious of what had to go into the books in addition to what he personally was attracted to.

DF: *Apple Tree—Full Bloom* is, in fact, from the book *Time in New England*. How did that project come about?

WN: *Time in New England* came about through his association with Nancy and Beaumont Newhall. He enjoyed his first one-man show at the Museum of Modern Art in 1945, after which he traveled in New England with Nancy.

AL: They were working together and independently on the book. While he was traveling around New England looking for various subjects to record with his camera, she was doing research in New York and Boston, looking for text passages dating from the time of the first settlers in New England to the late nineteenth century. The idea was to match the texts that she found with his images in a book that would be meaningful to the history of New England, the people of New England, and, in a larger sense, American history and the freedoms associated with America.

MR: I have a technical question that relates to this print, which is gelatin silver. Given Strand's interest in straight, unmanipulated materials, and the fact that he spent so much of his career using platinum paper, does anybody know why he changed? Was it because platinum paper was no longer available?

NR: That's one reason, but he also changed because he had a different view of photography. In the early 1920s Strand wrote that he used platinum paper because it had a long range of values, which silver paper at that time did not have, and because it would last forever, he thought, whereas silver would deteriorate.

MR: Relative to a modern gelatin silver print, platinum is a printing process that really calls attention to itself in its object quality, no matter what the imagery, whether it's the fuzzy forest we saw in the beginning (pl. 1) or something really sharp. The other factor that might play into his switch to silver, of course, is that he was printing for reproduction. The reflective blacks in a silver print are better suited for this. A platinum print can look very flat when reproduced as a gravure. There's something pictorial about all the work to this point that has nothing to do with focus or substance. It has to do with the actual physical qualities of the prints.

WN: I just adore this picture. The first thing we see is a blossoming fruit tree that seems to be trying to explode out of the frame; it's so laden with flowers that the idea of fertility is ever present. There are other details that are easy to overlook. For example, right below the tree is a huge rock, covered with lichens and some of the white petals that have fallen from the branches. Toward the lower left corner there's a piece of wood going into the tree that seems almost as if Strand put it there to provide structure for the picture. There are no clouds in the sky, like we saw in the Gaspé (pl. 16) and New Mexico (pl. 19) pictures. The sky here appears to be perfectly clear. The sense of solitude and tranquility is almost overwhelming to me.

MR: Well, it's the one I'd take home. I'm knocked out by how both the imagery and the printing integrate so well. It's really astonishing.

AL: This photograph is just in full bloom. There's something very positive about it, partly due to the way the blossoms fill the whole frame. What's interesting is that at this time Strand was becoming increasingly disillusioned about what was going on in the country and what its future was.

AT: I see this as a picture of an explosiveness of natural growth, just bursting. But what bores me about that, I guess, is that the idea is so obvious. I grant that the photograph has certain pictorial values that are engaging—this is a gorgeous image—but I don't see that it has anything whatsoever to do with New England or with America. It has to do with the bursting forth of new life in an apple tree.

AL: You can separate it as a single image, but the fact of the matter is that he didn't single it out. He included it in this book, and the images and the accompanying text are meant to be read in a very specific way.

AT: Are there notes in the way of a scenario in which Strand wrote to himself, "Let me go get an apple tree, let me go get a rock"?

AL: Yes. He wrote to Nancy Newhall on June 19, 1946, "I am trying to get an apple tree in bloom."

NR: But there was a long correspondence between Strand and Newhall about what the book was supposed to have in it, and what they were doing. We have to separate this from the photographs we've talked about up until now, because those were intended to be seen as single images.

AT: Imagine being a photographer on this day. The reason that he made this picture is that he came upon this thing, he stood there, and he quivered. He quivered! I mean, he got hot for this tree, and that's why he made this image. Don't tell me about *Time in New England*! That comes down the line, but at the moment, this is it. He captured that moment brilliantly.

WN: I think that we're dealing with recording experience here. It's a side of Strand that we don't see very often, one that's closer to Henri Cartier-Bresson, who made his work by seeking out and recording experience.

NR: This may interest you. Strand wrote to Sam Hootz in 1931: "Photography is a medium I love to work with, which is part of my bones. . . . I know that it can be made the means of an utterance as clear, as grand, as alive as any I know of in the world's art. . . . Camera materials, paint, clay, words, are all what they are—material—until they fall into the hands of someone who having lived deeply and beautifully utilizes them . . . to put that living into form as vision, as song, as some kind of clear saying."

MR: In relation to everything else we've looked at, this is the one picture by Strand I'm really interested in where I don't think about how he did it. I really love that Gaspé picture, but what I love about it is contemplating all those little decisions he made. Here I don't consider his decisions at all. I'm just taken by the image.

WN: I don't think any picture that we've looked at so truly manifests the vitalist spirit as this one does. The reason I think of it as such a triumph is that he had worked for thirty years, and here's a picture that is brimming with vitality, which

fulfills his self-stated objective. Whenever any of us sets an objective and then achieves it so brilliantly, it's got to be a moment of great joy.

DF: *Time in New England* wasn't published until 1950, the year Strand went to France and continued photographing with a mind toward book publication. These two images, *Houses, Locmariaquer, Finistère* (pl. 32) and *In Botmeur, Finistère, France* (pl. 33), both from 1950, were included in his 1952 book, *La France de profil.*

NR: The situation in the United States had become very difficult for people with liberal or radical ideas. The House Un-American Activities Committee had emerged, and some individuals who were suspected of being communists had had their passports taken. Strand felt that he didn't want to live in a country where there was such a restrictive atmosphere. He also wanted to be able to travel, and he didn't want to lose the ability to do that.

His second marriage, to Virginia Stevens, had also broken up by this time. He met Hazel Kingsbury in New York, and the two of them departed for France, where they expected to collaborate on various projects. He had in mind the idea of finding a village where he might settle and continue his book work. They moved to Paris, bought a car, and began to look around for this village. He wrote in a letter in 1950 that they had traveled some thirteen hundred kilometers—to Normandy, northern France, Alsace and Lorraine, the French Alps, and through Burgundy—and he had made at least four hundred negatives. Eventually, however, his passport expired, and for most of the 1950s he couldn't return to the United States. He didn't need it to travel in France, but he couldn't come back to the United States and get out again. So he bought some property about thirty-five kilometers outside of Paris and settled in to continue his life's work.

AL: Strand couldn't return to the United States because the government believed he was a communist and in 1954 issued instructions to withhold his passport. Letters were then sent to him at his old Paris address, asking him to call at the passport section of the American Embassy. It is possible that he didn't seek to renew his passport for fear that it would be withheld.

NR: I think Strand ignored the letters requesting that he turn in the passport but in all probability contacted a lawyer in the hope that the decision would be reversed.

He, along with a number of other people, instituted a court case, and eventually, in July 1958, he was issued a new passport. He probably hung on to the old one until then.

DF: Mark, it strikes me that these two photographs represent the dichotomy in Strand's work that you've talked about, one being composed and the other more centrally focused.

MR: They're both composed, of course, but in *Houses*, the composition is actually the content, whereas in the other, the composition is presenting the content in a clarifying manner. It doesn't call attention to itself.

 Houses has a strange spatial illusion. It's what I would call a very clever picture, which I don't find as appealing, because once a picture like that reveals its secret, I don't have to see it again. *In Botmeur* grows on you. I'm sure every time I'd see this picture, I'd think about it in some new way or see something I hadn't seen before. It's deceptively simple, whereas the other one is obviously complex.

AL: *Houses* is an abstract composition like what we saw in Gaspé or New Mexico. The light infuses the photograph with content; the structure is molded and takes on new forms through the shadows. Yet I agree with Mark about coming back to *In Botmeur* and seeing something different each time. There's an engagement here that doesn't exist with the other print.

MR: It's quite a remarkable tree in its own sad way!

WN: These two pictures are important because they're made in the same general place, where the architecture is roughly the same, and yet they seem to be absolutely the inverse of each other. This is very much in keeping with Strand's idea of plasticity, of using the photographic materials to shape the way he sees what is before his eyes.

NR: It's odd to me that Strand made a picture like *Houses* in 1950, a time when Abstract Expressionism was prominent, because he was strongly against it. He was infuriated by painters such as Hans Hofmann or Mark Rothko, and even by some photographers.

WN: So Strand would have been antithetical to Aaron Siskind?

NR: Absolutely. He called him America's "crack" photographer. Yet this picture is very similar to a Hofmann painting. I find it strange that Strand reacted so negatively to Abstract Expressionism and then made this picture.

WN: Of the works we've looked at today inspired by the dialogue between man and nature, *In Botmeur* is one of the most satisfying. I've always thought it symbolic of the way French horticulture works—the way they cut the trees, which then stretch and break out of their confinement. There's something optimistic in the breaking out of bondage.

AL: I don't see this as positive at all. In fact, I find this a very depressing image, because there's something pathetic about the tree caught between those buildings. It can't grow the way it's supposed to! It's almost fettered.

AT: Rather than thinking of the tree as being constrained by the two buildings, I see it as joining them, filling that space with something that is of comparable interest to the structures while being fundamentally different from them. Both of those houses would be framed by wooden beams, presumably, so the tree becomes a kind of metaphor for the buildings.

NR: When this appeared in *La France de profil*, it looked altogether different, because it was accompanied by a very lively, witty arrangement of a poem on the opposite page (see p. 128), which makes it much less dour than it looks when you see it as a single image.

It should be noted that Strand had absolutely nothing to do with the layout of that book. He handed the pictures to Claude Roy, who wrote the text, and said, "Do what you will." Roy added a French spirit that took the pictures into a different context. To me, it's the best book produced from Strand's work.

AL: I have a question not only about this book but also about *Un paese*, the Italian volume. Strand didn't speak French or Italian. We know he was an advocate for merging text and images in his books, but how well did he grasp the words that were accompanying his pictures? Was he supplied with an English translation?

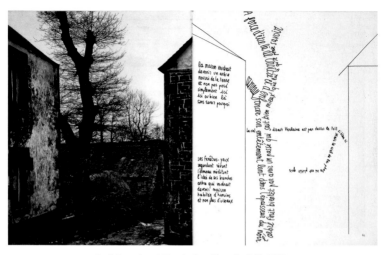

Paul Strand and Claude Roy (French, 1915–1997).
La France de profil, 1952. © 1952 Aperture Foundation, Inc.,
Paul Strand Archive.

NR: He had friends who translated it.

AL: I'm curious how he perceived it. Was the book laid out and printed before he saw it? Or did he actually have an English translation as a maquette?

NR: He saw the book before it was printed. In fact, he went to the printer and helped print it. After the experience of *Time in New England*, which he thought had poor reproductions, he vowed that he would never allow a book to be produced without overseeing how it was made. But whether he had read the text before, I do not know.

DF: Anne mentioned the book published in Italy, and our next photograph—*The Lusetti Family, Luzzara, Italy*, from 1953 (pl. 37)—is from that project, *Un paese*.

NR: Strand had the idea of finding a village with ordinary people and photographing it extensively. On a trip to Italy he told Cesare Zavattini about his idea, and Zavattini took him to look at various villages. One of them was Luzzara, where Zavattini had been born. He introduced Strand to the Lusetti family.

AL: Basil Davidson, who later worked with Strand on *Tir a'Mhurain*, recounts looking at this image with Strand and asking how he managed to get all the subjects in that position. He thought it was luck. Strand told him that he orchestrated it, but it was just by chance that he came upon the scene.

MR: This has a natural feel to it, but I don't really believe it. It's a posed portrait, but what's wonderful is that they're all posing in a different way. You have a sense, whether it's fictional or not, of five different personalities here.

AL: They're allowed to be themselves within this group portrait.

WN: When I first saw this picture, I wanted to believe completely that Strand found his subjects in just this way. But after a moment's thought, I knew that he could not have.

AT: But that is the way they are, because the only reality for us is this picture.

AL: Yes, but there is also a variant of this image with the figures in almost the same poses, only with an additional person in the doorway. I think this is worth noting in this context, given the father's partisan history and the fact that he was persecuted and ultimately died. One image has a void in the doorway; the other version has one of the sons standing there. I think Strand is deliberately arranging both scenes to call attention to the father's absence.

NR: Like many Strand images, there are things that happen in the picture that he was not conscious of at the time, but that may have been unconsciously motivating him to place people in certain ways or leave certain areas empty.

WN: The elements that couldn't be invented here are interesting—the deteriorating drainpipe, the way the cracked stucco looks on the wall behind the man at left, and the light coming through the window to the right of the mother. There's a miraculous combination of perfection and its opposite. Perfection in the people; they're handsome, strong, alert. And yet everything around them seems to be undergoing decay.

NR: Yes, what Strand calls "junk disorder around the people," and yet he made them into this almost iconic image.

MR: Given everything going on here—a five-by-seven-inch camera, film holders, the tripod, he doesn't speak Italian, and he's working with five animate subjects—he's probably not thinking consciously about that little half-moon shape of light in the doorway. But it works so wonderfully in the picture. I think good photographs almost always contain this: no matter how controlling the approach, there is always an element of the unexpected. I think a lot of photographers don't even see it when they're done. Somebody else comes along and says, "Oh, that's amazing."

DF: We're going to close our conversation today by looking at two photographs from the project that resulted in the book *Tìr a'Mhurain*. The first is *Norman Douglas*, from 1954 (pl. 42).

NR: I'm sorry to say that I find *Tìr a'Mhurain* the least interesting of Strand's books. He said that this was a case where he had to photograph things he might not have been interested in because he was trying to tell a story of the land and its people. He said he could not let his personal feelings about what was interesting guide what would be in the book.

AL: But this was a self-initiated project, right? It wasn't a commission. It seems a bit contradictory that he felt he couldn't do what he wanted to do, yet it was something that he had initiated.

NR: I think he initiated a project that wasn't that challenging. He took on something that he hadn't done before, in a place that he didn't have a relationship with, and he wanted to see if he could work it out.

AL: There was some interest in the Gaelic culture at the time. It was a very oral culture; it still is, largely. Their tradition has been passed down mainly through songs and through the spoken word. Strand had heard a program on the radio that featured a Gaelic singer from the island of South Uist, and it appeared to spark his interest.

WN: We should talk for a moment about a recurring pattern in Strand's work evident in this photograph. At some point, starting with *Time in New England* and moving to *La France de profil* and then to Italy and now Scotland, he began to photograph people in their context, and that context is most frequently a wall. The precedent for this, of course, is the wall behind the blind woman (pl. 7).

AL: It's a convenient backdrop, an outdoor studio, if you like.

WN: Right. It's an organizing principle.

AL: He didn't intend the wall to give a context. He didn't want to distract the viewer, so he makes the observer focus on the subject. At the same time, the wall creates an equality for all these individuals. Rather than showing people in different situations, or alluding to social class or standing, it's just a wall. You're not meant to read into it.

NR: This is from a conversation Strand had with Robert Katz in Orgeval in August 1962: "The whole question of portraits is a very interesting one. For me, a portrait should be of interest to people who have never met the person and don't know anything about him. If it isn't interesting in that sense, it isn't a portrait. . . . The old man in the poorhouse of Luzzara is an immortal image. Nobody who looks at this portrait will have known the old man—but still, they could be deeply interested and moved by his image." He went on to say that when you add words to a portrait, it adds a dimension, and "a marvelous alchemy takes place." So he was thinking of these portraits as being part of the book, part of the narrative that was engaging him at the time.

DF: The second photograph from the *Tir a'Mhurain* project—*White Horse, South Uist, Scotland*, from 1954 (pl. 47)—is very much about context.

AL: I wanted to include this because the white horse is an interesting element in Strand's work that appears throughout his career. One of the first examples is in Gaspé (see pl. 15). It seems to me that there has to be something to the fact that it recurs in his pictures.

NR: Meaning that the white horse is a metaphor for something?

AL: Maybe, but I don't know what that would be. Other white structures—buildings, for example—also recur. It may be something as simple as Strand looking at the white elements on a dark ground and exploring the range of tones that he could capture. With the horse, however, because it's an animate being, there's something more enigmatic; I guess I'm searching for it to stand for something. I think back to Stieglitz and his photograph *Spiritual America*, with the castrated horse. That was clearly symbolic, and my wondering if there is something here comes from that.

WN: I think we see here a search for archetypal beauty and strength. The element of the Pictorial comes back in an image like this. It would almost be easy to see this as a calendar illustration, not the work of someone who is a philosopher in the art of photography.

AT: But the spacing of the picture—the relation between the figure of the horse and the hills, the rise behind it, and the foreground and the sky—keeps it from being calendar art. This has the quality that Strand achieves at his best, a tense harmony of elements.

NR: He also photographed this because he felt horses were important in this culture. He couldn't leave it out.

MR: Something else that separates this from calendar art is not just the scale of the print—which is roughly five by six inches—but the incredibly dark printing of it. It's a tour de force of a certain kind of printing; it's about the language of photographic prints. The printing is extremely controlled but at the same time very eccentric in how dark it is without being black. And, of course, we have to remember that the actual horse is big; it's tiny in the picture. So the horse has a similar life in this picture to that little white triangle in the Gaspé picture (pl. 16) in its scale and its relationship to the predominant dark masses. They're not black, just dark.

WN: The Gaspé picture of the white shed is perfect because the light illuminated the scene in a way that we have to imagine is going to disappear. The light here is equally interesting, and that's probably what connects the two pictures. There is an element of perfection about all the elements. He found the horse in that position, and with the light and the sky he had all the things he needed to make a very beautiful picture. He seized the moment and gave himself over to it, in a way, like with the blossoming apple tree, where he was overcome by the beauty of the moment that he happened to find himself in.

AL: It's an important point that, throughout his career, Strand was extremely patient. He was willing to wander around waiting for an image to appear. He might see a spot with potential, but he knew there needed to be a combination of elements to make it right for his pictures. He was always thinking photographically, but he waited for the right moment, not in the way of Cartier-Bresson's decisive moment,

where you instinctively shoot as soon as action happens, but with a more considered respect for time.

NR: Strand called it digging around, and that's exactly what he did. He hung around, and he waited. He had infinite patience, the kind that could drive you crazy. I think that resulted in his finding these kinds of images.

DF: We always conclude our discussion by having each of the panelists give a few summary remarks about how the day has affected their thoughts about the artist. Alan, why don't you begin with your ideas about Strand.

AT: In my view, the interest that Strand's pictures present is their embodiment of certain contradictions. It's a given that he is, as far as photographers go, one of those in the history of the medium with an extraordinary eye. What he shows in his pictures is so often what viewers like me wish to continue to see. His pictures offer a constant sense of visual nourishment that comes from all the elements of the photographic experience—textures, composition, perspective, and light.

But what gives him a special quality is that he seems to be torn between one view, which is to accept the given nature of the world, and another view, which is to process the world intellectually. That could lead to an idea of vitalism; it could be organicism. But that attempt to translate the world into an idea means that, for me, his pictures often go beyond the self-sufficient and point toward some allegorical dimension. I think that is an interference with the basic photographic experience, which is sensuous and best represented in pictures like the apple tree (pl. 31), the white horse (pl. 47), and the blind woman (pl. 7), which are subjects he simply accepts within the parameters of his equipment.

MR: I confess to not having a great in-depth knowledge of Strand's career, except for certain key pictures, some of which we have talked about. What I find most interesting at the end of this colloquium are the contradictions in thinking about photography and art that I deal with all the time, both as an artist and a teacher. I'm referring to how imagery and ways of thinking about photographic imagery move from an idea of a medium that's answerable to the world and the political sphere to the social realities of the time and place of the maker and then to the audience and a more detached intellectual art.

We've seen this in the very small sampling of Strand's pictures we've looked at today, and that's characteristic of the fascinating problems of art in general. We're still arguing about things that they argued about a hundred years ago. I think it's partly because of the peculiar nature of the medium itself. We never get tired of saying that, but somehow it's still peculiar.

AL: I always go back to the moment when the photographer was working. I'm so much a product of my own time that, in researching Strand, I remember being amazed to find out that he didn't have electricity in his apartment when he first started to work. So I try to put myself back into the early twentieth century and see what he was trying to do with his photographs, to understand how much of a Modernist vision they have and how groundbreaking they were. We're so familiar with them today that it's hard to shake that familiarity and go back with fresh eyes to see them in the context in which they were made. As we've talked about these pictures today, there's been a sense of trying to figure out what was going on, but at the same time, our own histories come into it and influence how we read and react to them.

And Strand's career itself was so long! We've only covered forty years, given the parameters of the Getty's collection, but it's amazing that in those forty years he came such a great distance from, say, *City Hall Park* (pl. 2) to the horse in South Uist (pl. 47). And yet, in all those years, the same themes recur. It's interesting that, as an individual, he was traveling all over, but more importantly, that he was wrestling with the same problems of the medium and trying to reconcile those.

NR: What Alan finds contradictory in Strand, I find engaging. I am not as interested in the individual images, although there are some that I absolutely love. I am more interested in the ideas that motivated him throughout his life and what he felt photography could do—how it can change people's perceptions about life and places, how he swung back and forth from being very concerned with the formal means to being concerned with social or political ideas. That's the area of his work that really engages me. I'm more interested in the context in which he worked, what was going on around him. And, in particular, in something we didn't discuss much today, which is how his political ideas affected what he was doing.

WN: I share with Alan a genuine interest in the element of the contradiction, but what I really admire about Strand is the aspect of him as a wanderer. He is one of the few pioneers of Modernism who traveled frequently, far from home, to make pictures that reach below the surface, while never losing sight of the formal requirements that Modernism imposes. Even though photography can't really do anything more than show a surface, Strand seems to find a way to get below it. I admire the way he made photographs that represent the world at large and also exist as aesthetic objects that are separate from and, I'll use this word that we've talked about, *equivalent* to, the natural objects that they represent. So the aspect of representing the world and being an equivalent of something else is the contradiction that engages me with Strand's work.

AT: Before we conclude, let me ask Naomi one last question. Is there one of the photographs we've seen today that you would call specifically political?

NR: I didn't say there were political photographs, but that he had political ideas that affected the kinds of photographs he made.

AT: What's an example of a photograph that was affected by his radical political ideas?

NR: All of *Time in New England* is a political statement, in a way, because it was made to celebrate an idea that Strand and Newhall felt was being perverted.

AL: Liberty.

NR: Yes. The basic constitutional liberties. But I don't think individual pictures necessarily do this.

AL: With *Time in New England*, I think Strand was saying that he was proud to be an American, that he loved this country. The photographs showed the things he loved about it—the natural landscape, the history, the people, and everything they stand for. The book is very backward looking. It's not looking to the future, and I think that was deliberate on his part. He really didn't know what the future held, but he felt that the situation in the late 1940s was threatening.

AT: But why call that political rather than, let's say, ethical?

AL: Because of the fact that he was driven out of the country. He saw art as something that was being threatened by the government at the time. I see that as political.

NR: What do you mean by ethical instead of political?

AT: An ethical position is one that is based on a distinction between right and wrong. But what I'm trying to say is that what would be political as distinguished from ethical is the identification of certain forces, either in or outside of government, that are mistaken and need to be corrected in certain specific ways. Then you're being political.

WN: Alan asked if any of the pictures that we saw today have a political element. If there's one single image we could call forth, I would say it's *The Lusetti Family* (pl. 37), because that entire series was motivated by political beliefs. Strand was attempting to do exactly what you said—to right a social wrong by showing the barefooted people working honorably in an industrial location, with dignity but without a lot of compensation. It took me a long time to understand what the political element of Strand's work was, because it is so much about beauty. Even the family in Luzzara is a beautiful picture before it is a political one. That's part of the contradiction we've found in his work.

MR: I think some of the Italian portraits are really remarkable images, but there's a kind of picturesque quality to them. For me, it's problematic that he didn't also photograph members of other social classes, because otherwise what he's saying is that these people reflect the noble-peasant cliché. Invariably, that supports the status quo, and it's a reactionary kind of political position.

NR: You can consider that being so today, but was that true when he was making the photographs? Can we look at what he was doing in the past with today's eyes and today's concepts?

AT: If we don't, then we're just being historicist and saying that what happened then doesn't matter much to us today, except through an antiquarian interest. But we want to say that Strand is a still-living artist and that his work means something to us today. To say that such-and-such a picture has political power because it did so to him at that time—even though, as Mark has pointed out, it may not

have any self-evident political implications today—needs to be taken into account. Something has happened between then and now.

When we're looking at anything, or engaging in an activity, we're concerned with what it means. Certainly in looking at photographs we're concerned with meaning. But meanings are not intrinsic. They are situational and a product of interaction and construction. There is no such thing as an inherently political photograph. Even though there may be signs in the Lusetti family photograph of a political position, that doesn't make it inherently political to me. It becomes political, or it ceases to be political, in our process of dealing with it, discussing it, exchanging ideas about it. Like the apple tree. We could make that into a really profound political statement if we wished, and I was going toward that in suggesting that it has the bursting quality of rebirth and so on. But I think it is a mistake to say that the political aspect is already present as an intrinsic quality.

WN: Strand might not have admitted to anybody that his pictures were political, but it was impossible for him to have been educated at the Ethical Culture School and not have absorbed, directly or indirectly, a political interest.

NR: I agree.

WN: Part of this dialogue process is that we've all shared knowledge of the very process of the way art comes into being. The fact that our discussion of Paul Strand has continued in such a spirited fashion after we've all made our concluding statements is an indication of the attraction that his photographs have for all of us individually. A lot of knowledge from our collective experience has been put forth today that is not printed in any book, but will be in our In Focus series. So thank you all for agreeing to participate.

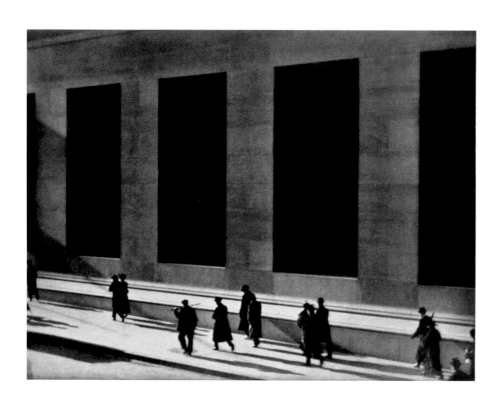

Paul Strand.
New York, 1916 photogravure from a 1915 negative,
13.2 × 16.4 cm (5 ⁵⁄₁₆ × 6 ⁷⁄₁₆ in.). 93.XB.26.50.2.

Chronology

1890

Paul Stransky is born on October 16 in New York City to Jacob and Matilda Arnstein Stransky (last name later changed to Strand).

1902

Receives first camera, a Kodak Brownie, as a gift from his father.

1904–8

Attends the Ethical Culture School, New York. Studies with the photographer Lewis W. Hine, who in 1907 exposes Strand to Alfred Stieglitz's Little Galleries of the Photo-Secession (later 291). Joins the Camera Club of New York as a nonresident member.

1909

Graduates from the Ethical Culture School, works in the family enamelware business, and photographs on the weekends. Becomes a full member of the Camera Club.

1910

Participates in the annual members' exhibition of the Camera Club. Experiments with soft-focus lenses, gum prints, and enlarged negatives.

1911

Travels extensively around Europe for six weeks. Wins third prize at the annual members' exhibition of the Camera Club, which also publishes one of his images in its journal. Works as an insurance clerk at Great Eastern Casualty Co., New York.

1912

Becomes a commercial photographer, making images of colleges to sell to students

and alumni. Wins honorable mention at the London Salon at the Haywood Gallery.

1913

Attends the Armory Show, New York.

1914

Continues to visit 291 and occasionally shows Stieglitz his photographs for advice. Exhibits in a group show of Pictorial photography at the Ehrich Gallery, New York.

1915

Exhibits in a group show of Pictorial photography at the Print Gallery, New York. Travels across the United States, continuing to make and sell hand-tinted photographs of colleges.

1916

Has first solo show, *Photographs of New York and Other Places, by Paul Strand*, at 291 in March–April. Spends summer at Twin Lakes, Connecticut, where he works on his first abstractions. In New York, makes street portraits using false lens. Six photographs are published in *Camera Work* in October.

1917

Wins first prize for *New York* (see p. 138) at the *Twelfth Annual Exhibition of Photographs* at John Wanamaker, Philadelphia, in March. Exhibits in *Three Photographers* at the Modern Gallery, New York, with Charles Sheeler and Morton L. Schamberg, also in March. Eleven photographs are published in the final issue of *Camera Work* in June (see p. 140), which also prints his essay "Photography," written for the August issue of the *Seven Arts*.

Alfred Stieglitz (American, 1864–1946).
Camera Work, June 1917.
Printed journal with mounted photogravures,
31.6 × 23 cm (12⁷⁄₁₆ × 9¹⁄₁₆ in.). 93.XB.26.51.

1918

Wins second and fifth prizes at the *Thirteenth Annual Exhibition of Photographs* at John Wanamaker, Philadelphia, in March. Travels to San Antonio, Texas, on behalf of Stieglitz to persuade Georgia O'Keeffe to relocate to New York. Is inducted into the U.S. Army, where he works as an X-ray technician in the medical corps at Fort Snelling, Minnesota.

1919

Contracts influenza during the epidemic sweeping the country. His mother is also infected and dies. By the end of July, completes military service and returns to New York.

1920

Receives first prize at the *Fourteenth Annual Exhibition of Photographs* at John Wanamaker, Philadelphia, in March. Makes six-minute film with Sheeler, *Manhatta* (originally known as *New York the Magnificent*), captioned with Walt Whitman quotations.

1921

Manhatta opens on July 24 at the Rialto Theatre in New York.

1922

In January, marries Rebecca "Beck" Salsbury. Exhibits at the Municipal Building in Freehold, New Jersey, in June. Participates in the annual members' exhibition of the Camera Club in September. Acquires an Akeley motion picture camera and earns a living filming news and sporting events. Begins making photographs of Akeley equipment.

1923

At the Clarence H. White School of Photography, New York, delivers a lecture, which is later published as "The Art Motive in Photography" in the October issue of the *British Journal of Photography*.

1925

Exhibits in *Alfred Stieglitz Presents Seven Americans* at the Anderson Galleries, New York, in March, with Charles Demuth, Arthur Dove, Marsden Hartley, John Marin, O'Keeffe, and Stieglitz. Spends the summer with the sculptor Gaston Lachaise and his wife, Isabel, at Georgetown Island, Maine, making photographs of rocks and driftwood.

1926

Photographs in New Mexico and Colorado using a handheld Graflex camera.

1929

Solo show, *Forty New Photographs by Paul Strand*, is held at the Intimate Gallery, New York, in March. Photographs in Gaspé, Quebec, in September.

1930

Returns to New Mexico for one month.

1931

Spends summer in New Mexico making photographs of clouds, adobe structures, and ghost towns using Graflex and tripod-mounted view cameras. Exhibits in the *American Photography Retrospective Exhibition* at the Julien Levy Gallery, New York, in November. Reviews *David Octavius Hill: Master of Photography* by Heinrich Schwarz for the *Saturday Review of Literature* in December.

1932

Becomes an advisor to the Group Theatre in New York. In April, exhibits with his wife at Stieglitz's gallery, An American Place, New York, but has a falling out with Stieglitz. By summer heads to New Mexico, where his marriage dissolves. Travels to Mexico in the fall at the invitation of the composer Carlos Chávez, who is head of the Department of Fine Arts for the Secretariat of Education.

1933

Has a solo show at the Sala de Arte of the Secretariat of Education, Mexico City, in February. Is appointed the head of photography and cinema at the Department of Fine Arts by Chávez. Divorces Rebecca Salsbury in November.

1934

Is the principal cinematographer and cowriter for *Redes*, a film about Mexican fishermen. Loses his job at the Department of Fine Arts due to the change of government in Mexico and returns to New York.

1935

Travels to Moscow to join Group Theatre directors Harold Clurman and Cheryl Crawford. Hopes to work with the filmmaker Sergei Eisenstein but is denied a work permit. Returns to New York and joins the film group Nykino. Begins working as a cinematographer on Pare Lorentz's documentary about the Depression, *The Plow That Broke the Plains*.

1936

Marries Virginia Stevens, an actress with the Group Theatre. Returns to Gaspé in the summer to make a new series of photographs. *Redes* is released in the United States as *The Wave*.

1937

Becomes one of the founders and president of Frontier Films, a documentary film cooperative concerned with political and social issues. Coproduces and coedits its first release, *Heart of Spain*, a film about the Spanish civil war. Also coproduces the short documentary film about Chairman Mao, *China Strikes Back*, written by Ben Maddow. Participates in the first photography exhibition mounted by the Museum of Modern Art (MoMA), New York.

1938

Begins filming *Native Land*, a movie about the violation of civil rights in the United States. Joins New York's Photo League, acting as an advisor and teacher.

1940

A portfolio of twenty hand-pulled photogravures, *Photographs of Mexico* (with a foreword by Leo Hurwitz), is published in New York by Stevens in an edition of 250 copies. Applies for, but fails to receive, a John Simon Guggenheim Memorial Foundation Fellowship. Participates in the exhibition *Sixty Photographs: A Survey of Camera Esthetics* at MoMA.

1941

Shows Mexican portfolio and *Camera Work* gravures in an exhibition at the Photo League. Applies again for, but fails to receive, a Guggenheim Fellowship.

1942

Native Land premieres May 11.

1943

Makes a series of images in Vermont, his first serious still photographs in ten years. Applies a third time for, but fails to receive, a Guggenheim Fellowship.

1944

Becomes the chairman of the Committee on Photography of the Independent Voters Committee of the Arts and Sciences for [President Franklin Delano] Roosevelt. Lectures at MoMA on "Photography and the Other Arts."

1945

Has solo show at MoMA, which publishes his first major monograph, *Paul Strand: Photographs, 1915–1945*, by Nancy Newhall. Continues traveling in New England and begins working on another book with Newhall, *Time in New England*.

1947

Hired by George Waters of Kodak to create advertising photographs with their new Ektachrome film product, which he does not favor.

1949

Divorces Virginia Stevens. Visits Czechoslovakia in August, where *Native Land* is awarded a prize at the country's film festival. Meets the Italian filmmaker Cesare Zavattini at a film conference in Perugia, Italy.

1950

Time in New England is published. Moves to France and begins working on a series of photographs.

1951

Marries Hazel Kingsbury, a photographer. They initially stay in Paris before settling in Orgeval. Continues to travel around France working on the publication *La France de profil*.

1952

Publishes *La France de profil* (with text by Claude Roy), about the people and culture of rural France.

1953

Makes a series of photographs in Italy, focusing on the village of Luzzara.

1954

Travels to the island of South Uist (Outer Hebrides), Scotland, and spends three months photographing the people and the land for a book.

1955

Publishes *Un paese* (with text by Zavattini), about the life and land of the Italian peasant. Begins work on a series of portraits of prominent French intellectuals as well as views (mostly close-ups) of his garden at Orgeval.

1956

Included by curator Edward Steichen in the exhibition *Diogenes with a Camera III* at MoMA.

1959
Visits Egypt for two and a half months for a series of photographs.

1960
Makes a brief photographic trip to Romania and Hungary.

1962
Publishes book about South Uist, *Tìr a'Mhurain* (with text by Basil Davidson). Visits Morocco to work on a series of photographs about Arab life.

1963
Elected honorary member of the American Society of Magazine Photographers. Visits Ghana at the invitation of President Nkrumah to make a series of photographs of its land and people.

1965
Introduced to Michael Hoffman, the publisher of *Aperture* magazine, by Newhall.

1967
In March, awarded the David Octavius Hill Medal by the Gesellschaft Deutscher Lichtbildner, in Mannheim, Germany. Oversees the reissue of *Photographs of Mexico* as *The Mexican Portfolio* (with a preface by David Alfaro Siqueiros), coproduced by the Aperture Foundation and Da Capo Press.

1969
Publishes *Living Egypt* (with text by James Aldridge).

1970
Visits Spain and the Canary Islands.

1971
Selects images for a major monograph and a retrospective at the Philadelphia Museum of Art, which opens in November, then travels to Boston and St. Louis. The two-volume book, *Paul Strand: A Retrospective Monograph, The Years 1915–1968*, is published by Aperture.

1973
Becomes a member of the American Academy of Arts and Sciences. Visits the United States for the opening of a retrospective exhibition at MoMA and at the Los Angeles County Museum of Art. Undergoes surgery for cataracts in New York.

1975
Photographs in the backyard of his New York City apartment during the summer. Later, returns to Orgeval to continue work on his garden book.

1976
Dies from cancer on March 31 at Orgeval. The Paul Strand Foundation is established and later becomes the Paul Strand Archive of Aperture Foundation. *Ghana: An African Portrait* (with text by Davidson) is published posthumously. Also published posthumously are two limited editions of original photograph portfolios: *On My Doorstep, 1914–1973* and *The Garden, 1957–1967. Paul Strand: Sixty Years of Photographs* is issued by Aperture.

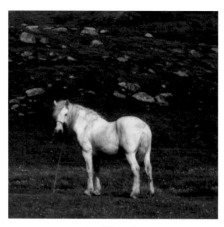

Paul Strand.
White Horse, South Uist, Scotland, 1954 (pl. 47, detail).

Project Editor	Dinah Berland
Editor	Gregory A. Dobie
Designer	Jeffrey Cohen
Production Coordinator	Stacy Miyagawa
Photographers	Christopher Allen Foster
	Rebecca Vera-Martinez
Research Associate	Michael Hargraves
Printer	Hemlock Printers Ltd.
	British Columbia, Canada
Bindery	Roswell Bookbinding
	Phoenix, Arizona